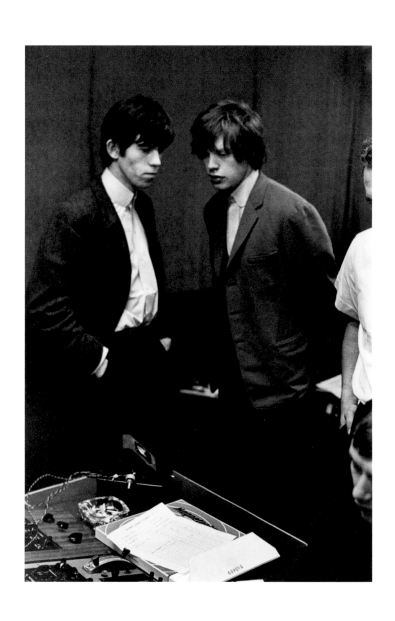

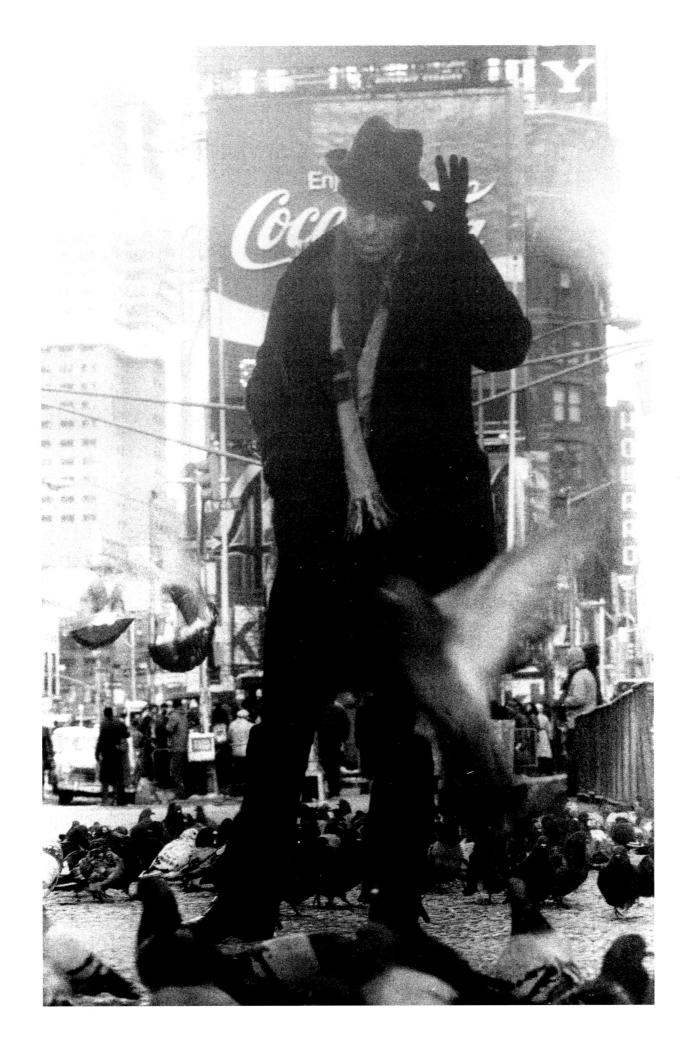

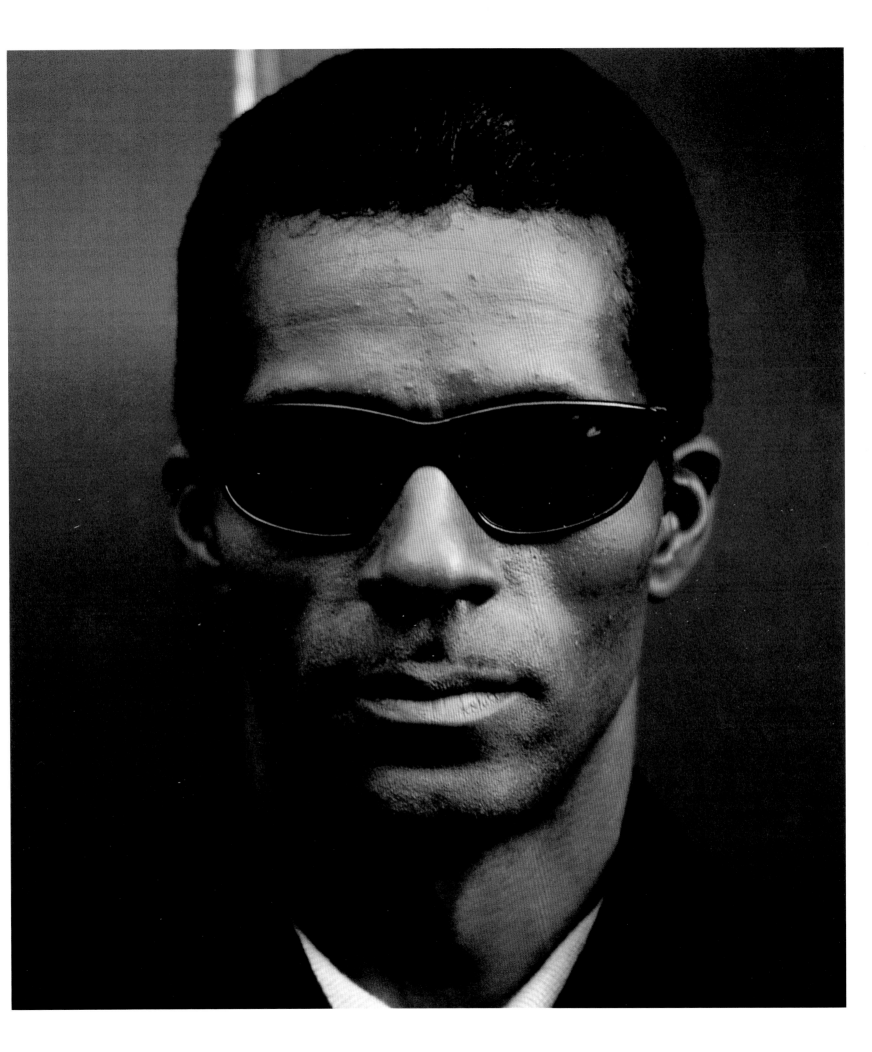

This exhibition and accompanying catalogue have been made possible by generous support from the Contemporaries and The VIA Group.

Backstage Pass
Rock & Roll Photography

Edited by Thomas Denenberg
Essays by Greil Marcus,
Anne Wilkes Tucker, Laura Levine,
Glenn O'Brien, and Kate Simon

Yale University Press, New Haven and London
in association with the
Portland Museum of Art, Maine

Once the pose become
puts down roots. A lot
here started out as fan
own idols became idols
photos were part of the
A pose is no good unles
are the poses that beca

habit, it takes hold, it
f the rock stars you see
and by imitating their
hemselves. And these
metamorphic process.
s it is seen, and these
me realities.

Glenn O'Brien

Blackness Greil Marcus

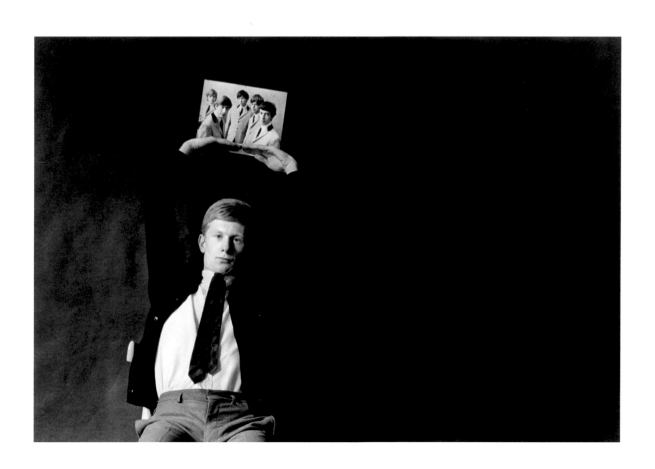

In this photograph from 1963, a young man seated in a chair holds up a picture. From his clothes, his hair, and the smug expression on his face, you might guess him to be a public schoolboy. Is this his favorite group? Are the people in the picture—people we now recognize, as we likely would not have when the picture was taken, as the Rolling Stones—people he would like to be? Or is he, perhaps in the way he positions the picture in his hands as if it is a top hat, signaling his superiority to the figures in the picture, the Rolling Stones as they were for their first television appearance on Thank Your Lucky Stars on June 7, 1963, a program that required them, against every blues instinct they had worked so hard to possess, to dress in identical stage suits?

The photograph is by Philip Townsend. The person in the chair is Andrew Loog Oldham, the manager of the Rolling Stones—nineteen years old, younger than anyone in the band. He is going to put them on one side, force the Beatles onto the field on the other, and fight and win a war. He is going to take over the world. "The Rolling Stones are more than just a group—" he would write on the back of their first album, in 1964, "they are a way of life."

The longer you look into the photograph, the more you are drawn to the black that dominates it—on the left, at the top, on the right—a whole room of blackness. "Presence in painting," T. J. Clark writes of the blackness in Jacques-Louis David's 1793 Death of Marat, "so the Western tradition seems to assume, is ultimately dependent on…a place where representation can efface itself, because in it there is little or nothing to represent. A wall or void or an absence of light." The photograph doesn't capture a moment; it shows what could not be shown: the future. The void into which, you can imagine, the man in the chair is about to pitch the people he holds over his head.

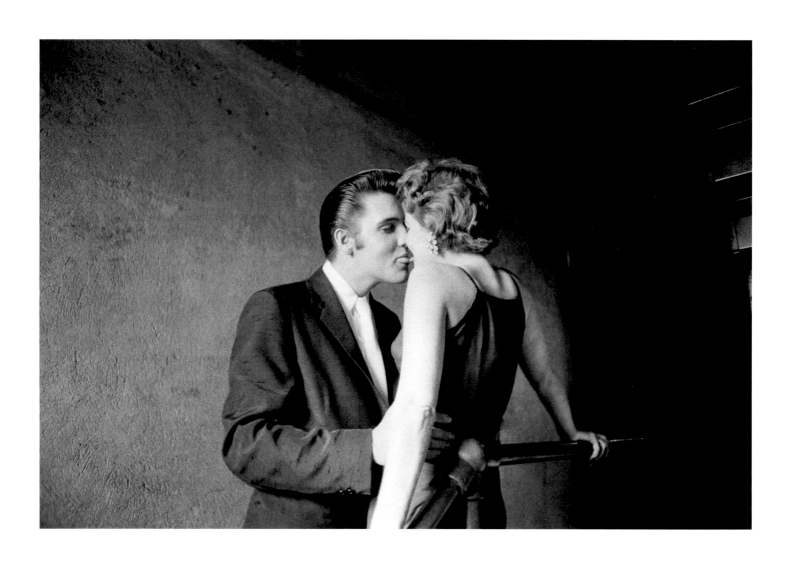

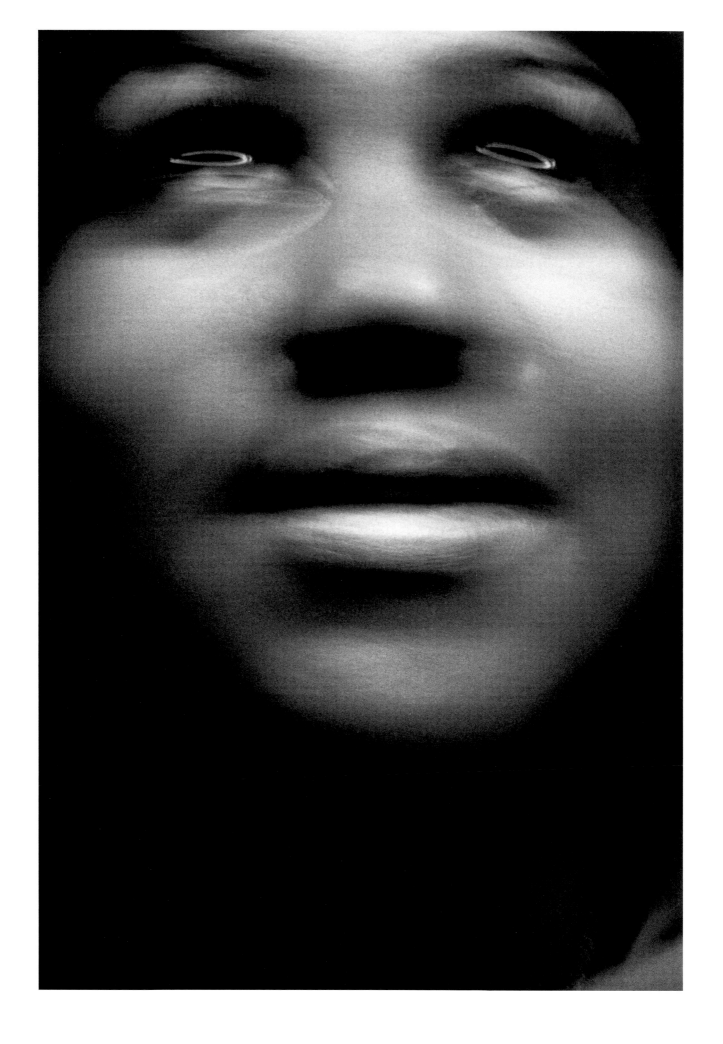

Rock & Roll and the Camera Thomas Denenberg

Rock & roll is an attitude, not a genre. Rock can be serious cool—Chuck Berry's quiet defiance, Mick Jagger's sneer, and the masculine bravado of Led Zeppelin. It can wink. Witness almost any image of the young, knowing Elvis Presley. Rock can play the fool. David Johansen's arch swagger and the punditry of Frank Zappa reveal a profoundly ironic worldview. Rock can be angry, rebellious, mean, flashy, in the groove, on the hunt, understated, supercilious, sentimental, and a desperate call for help all at the same time. Rock is a performance, onstage and off.

For five decades, critics and musicologists have parsed albums, songs, and lyrics in acts of exegesis that rival the religious study of canonical texts in search of rock's roots. The family tree is heavy with ancestors—blues, jazz, hillbilly, gospel, skiffle, and swing all antecede rock & roll. Survey the visual culture of rock, however, and another naturalistic metaphor comes to mind. It mushroomed. Rock grew exponentially beyond its roots, thrived in the atomic age, and heralded a psilocybin-informed backlash against the conventions of postwar banality. Rock & roll flourished during the era of late capitalism as modernist sensibilities of authority and celebrity permeated global culture at exactly the moment that new methods of production, marketing, and distribution could ensure that British adolescents gained access to African-American music.

Separating race from rock & roll is like removing salt from seawater. You can do it, but the product is something else. From syncopated work songs and field hollers of the nineteenth century through the birth of American jazz and onto the urbane sounds of Motown, rock & roll owes its largest debt to the musical traditions of the African diaspora and demographic shifts caused by World War II. Nineteen forty-nine marks a key moment in the development of rock & roll. In that year <u>Billboard</u> magazine reclassified "Race Records" as "Rhythm and Blues" and reoriented the marketplace for music theretofore intended for black consumers. By opening the door to a coming generation of white aficionados in the baby boom, this appropriation did more to engender racial harmony (and intergenerational discord) than will ever be measured. With a wide open youth market, the social conventions of jazz in particular—sophistication, detachment, and improvisation—lent themselves directly to rock & roll. William Claxton's 1960 photograph of John Coltrane in heroic profile at the Guggenheim is proof positive that musicians have long understood the role of cool in the presentation of self.

The relationship between rock & roll and the camera is intimate and profound. The photographer encounters the musician, and something is born that lives both between and beyond them. In the pages that precede and follow, Greil Marcus, Anne Wilkes Tucker, Glenn O'Brien, Laura Levine, and Kate Simon explore a catalogue of moments posed and stolen that illustrate a culture. Many of these images were commissioned, while others sprang from relationships between photographer and musician. All found their way into the life of a man who wishes to remain anonymous, so personal is this collection. He is, however, just offstage through-out the book. This volume is no nostalgia trip, no pantheon of heroic imagery, but a backstage pass to the history of rock & roll in the twentieth century.

The photograph doesn't capture a moment; it shows what could not be shown: the future. Greil Marcus

Taking pictures was a gesture of love. Kate Simon

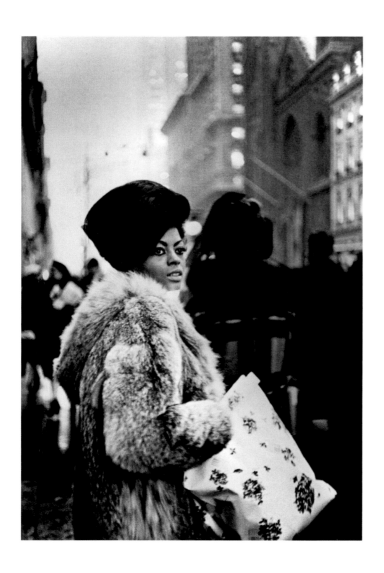

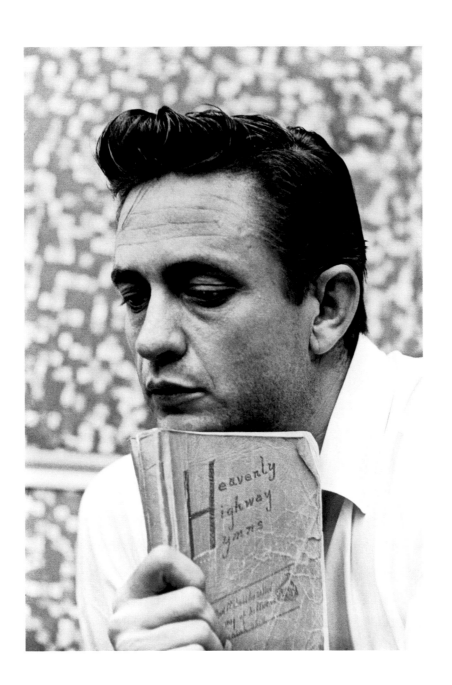

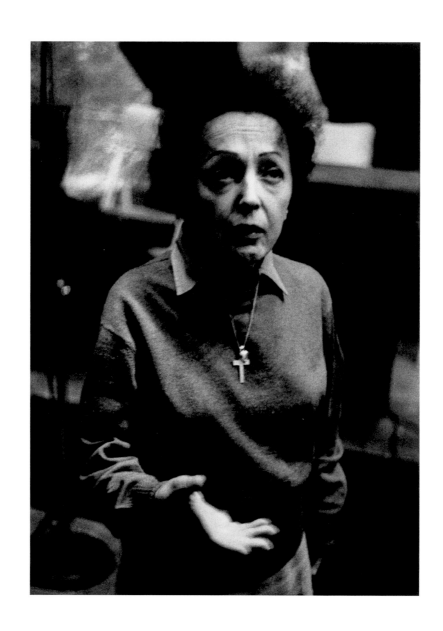

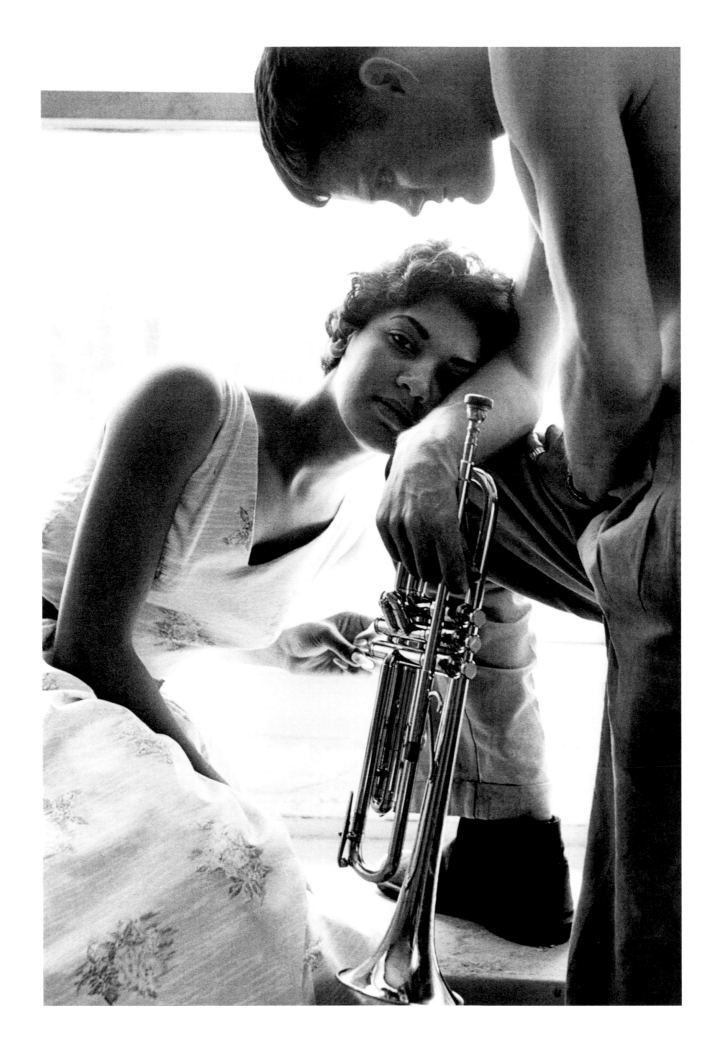

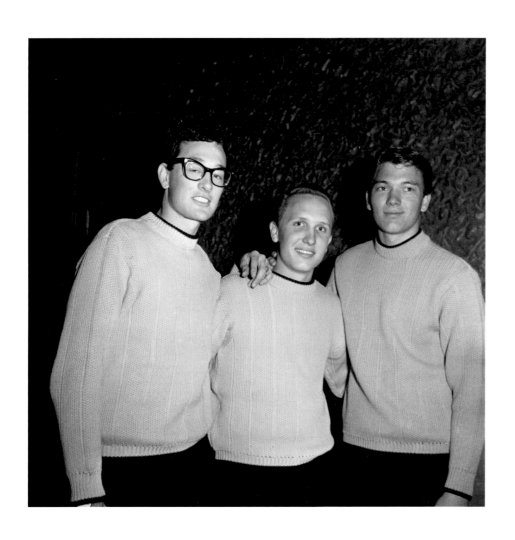

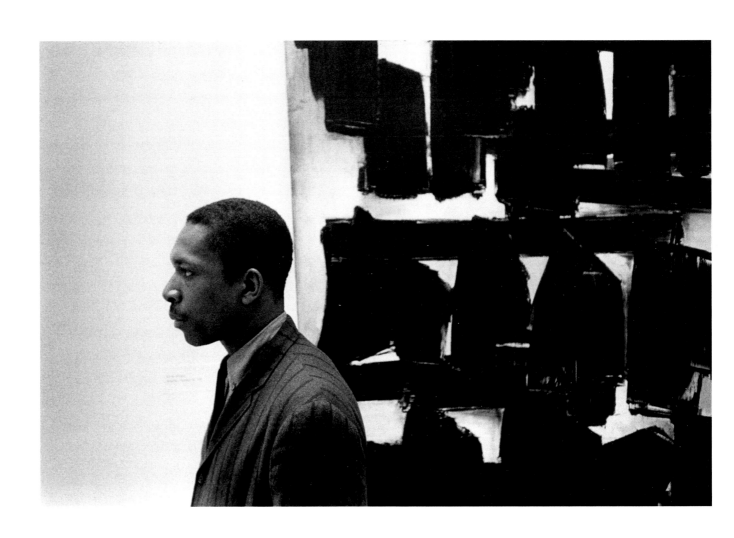

Remember When Anne Wilkes Tucker

William Claxton, one of the great photographers of jazz and rock musicians, cited his desire "to define the musicians as people, not just as performers." This gathering of photographs was built with a similar goal: to make musicians look "ordinary." Perhaps they appear as ordinary as talented nonconformist individuals can be. Ordinary people don't achieve and sustain this level of success or function productively in the publicity-driven, continually on-the-road, night-time-dominant lifestyles of musicians. Rebellion is their pleasure, maybe even their nature, but the collector's point is that they are, nevertheless, people with common concerns and daily lives. Several of them are his friends.

Accentuating the less celebrated aspects of their lives leads the collector to prefer photographs made early in the performers' careers, before they are too practiced in posing for the camera. He has also avoided photographs made of the musicians onstage. There are no scenes of the guitars pointed skyward, drummers pounding skins, backlit halos of floppy hair, flashing lights, or sweaty faces. None of the photographs of "Sir Mick" features his gyrating hips or him prancing down a runway, nor do we see the pyrotechnics of KISS or Pete Townshend smashing guitars. The most frenetic gesture is Susanna Hoffs's joyful midair split over her hotel bed, photographed by Laura Levine. Instead of the expected views, we see Jagger and Keith Richards looking simultaneously uncomfortable and surly in suits and ties or a very young Jagger standing inexplicably in a black bow tie and starched white shirt behind a large camera. In Lynn Goldsmith's photograph, Bruce Springsteen stands on a sidewalk in New York without being mobbed by fans, three years after he released his now-classic album Born to Run. Joni Mitchell appears ready for tea and conversation, as though we were just across the table. Her portrait, taken by Baron Wolman, the first chief photographer for Rolling Stone magazine, epitomizes what Wolman called "informal portraiture." Two other memorable informal portraits are Leigh Weiner's 1961 photograph of Johnny Cash holding his battered copy of Heavenly Highway Hymns and Claxton's 1955 portrait of Chet Baker with his first wife, Helima, tenderly resting her head against his knee.

Only a few of these pictures were taken in the studio—where the photographer is in control of the setting, lights, and pose—and therefore, the photographers' personal styles permeate the portraits. Missing here are the stark white backgrounds that signify a portrait by high-fashion and portrait photographer Richard Avedon and the staged-for-the-camera high jinks of Annie Leibovitz and Mark Seliger. Instead, most of these photographers preferred hanging out with the musicians and drawing them away from the stage or the studio. Their photographs reflect the spontaneity of a camera raised when the moment stirred them. Some of these pictures were taken outside, with the subjects standing by cars or other forms of transport; almost all are in urban settings. This is not a group for the bucolic scene. Faithful to the fashions of the sixties and seventies, many have dressed for the occasion in a floppy hat, a long cape, or a coat with military braid on the sleeves. The most obvious for-the-stage costumes are the silver lamé, space-inspired outfits worn by Patti LaBelle, Nona Hendryx, and Sara Dash.

No photographic collection about rock musicians is complete without some reference to frank sexuality. Included are Alfred Wertheimer's picture of Elvis in a tongue tickle, Roberta Bayley's photograph of Debbie Harry kissing Chris Stein, and Bob Gruen's photograph of Harry groping and being groped by Iggy Pop. "Blondie" was photographed by Kate Simon in a pose that Simon nicknamed "La Dolce Vita," referring to Anita Ekberg's sensual scenes in Federico Fellini's 1960 film masterpiece. Bob Gruen captured more overt attitudes toward "free love" when he photographed David Johansen with two presumed groupies who are clad in only underpants and high heels.

Photographs of the Beatles reflect different stages in their career. A photographer for Mirabelle magazine shot the young group while they still toured in business suits and well-trimmed hair, staged in a bizarre "party" scene with balloons and canapés on toothpicks. Lynn Goldsmith chose an angle that reveals only their shiny, pointy-toed shoes and rumpled suit pants. Sports photographer Harry Benson captured the boxer Muhammad Ali playfully throwing a punch at the Beatles, to which they responded by going limp and falling down. The publicity-savvy Ali initiated this session during the Beatles' first tour of the United States. Benson was Ali's official photographer. Three years later, Philip Townsend recorded the Beatles and their spouses seated at the feet of the Maharishi Mahesh Yogi, either on their first meeting at the London Hilton or a few days later, at a weekend "initiation" conference, in Bangor, Wales. This is just before the band released their fantasy-rich film and album Magical Mystery Tour, and they've abandoned business suits for vests and jackets cut from colorful fabrics and inspired by Asian styles. Other musicians shown in diverse observations by different photographers are Bob Dylan, Buddy Holly, Diana Ross, and the Who.

Perhaps not surprisingly, two of the most innovative portraits are by Art Kane, who photographed subjects ranging from rock and jazz musicians to fashion models. Both were taken in 1968. In his portrait of Aretha Franklin, Kane moved in so close that we see only her out-of-focus face with small halos of light inexplicably floating over her eyelids. In Kane's portrait of Jim Morrison, the legendary lead singer and lyricist of the Doors, Morrison backs into an empty closet and kneels behind a television with an image of a seminude woman on its screen. It is an appropriately elliptical view of the poet-lyricist, who remains legendary almost four decades after his death.

This collection acknowledges that musicians' lives are not all glamour and fun. It includes Barry Feinstein's picture of the paparazzi swarming around Bob Dylan's car, Bob Gruen's record of commuters on an airport bus casting disapproving stares at Sid Vicious, and Claude Gassian's late view of a forlorn Chet Baker. The most recent work in the show is Kate Simon's portrait of an emaciated Iggy Pop looking ravaged beyond his years. This is also the only image of a living, aging star. In fact, many of these musicians are now old or dead, while others—such as the Rolling Stones, Springsteen, and Neil Young—are still on tour. This show, however, is a record of another time, when their careers were more about hope, work, and scheming, and they weren't so certain that two to five decades later we would still be fascinated to "remember when."

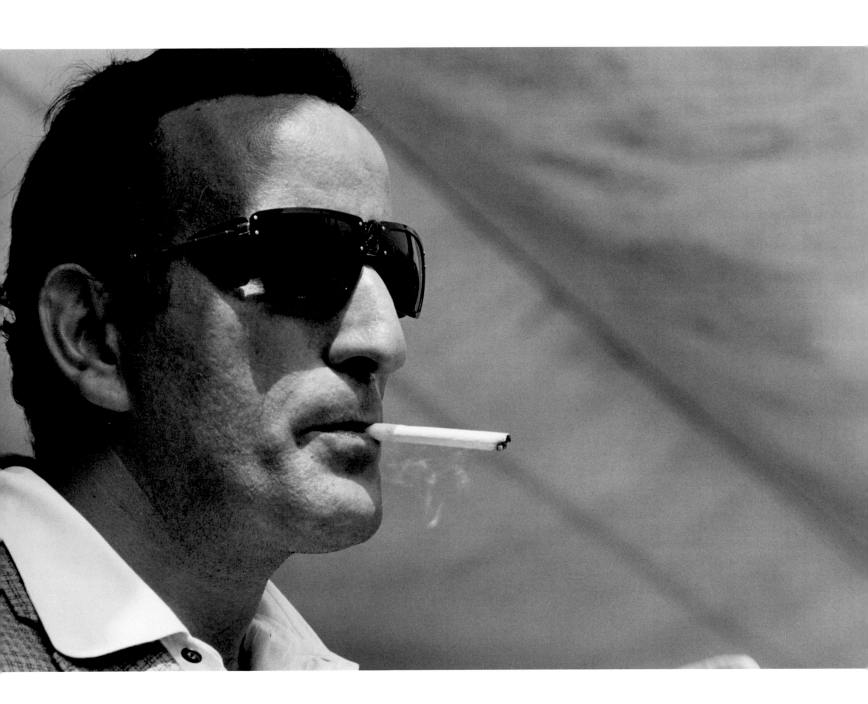

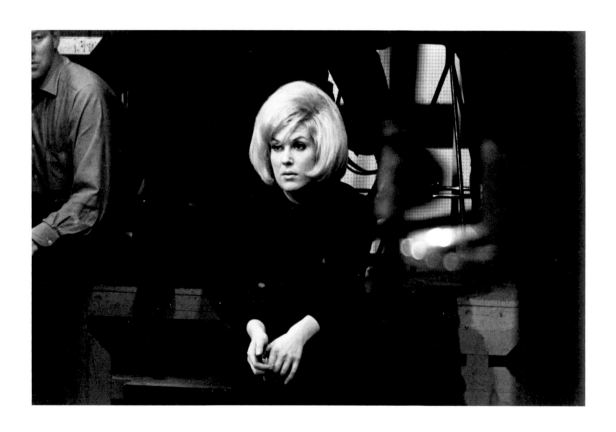

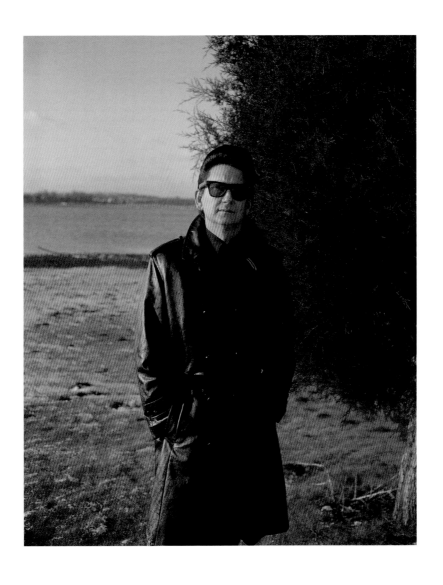

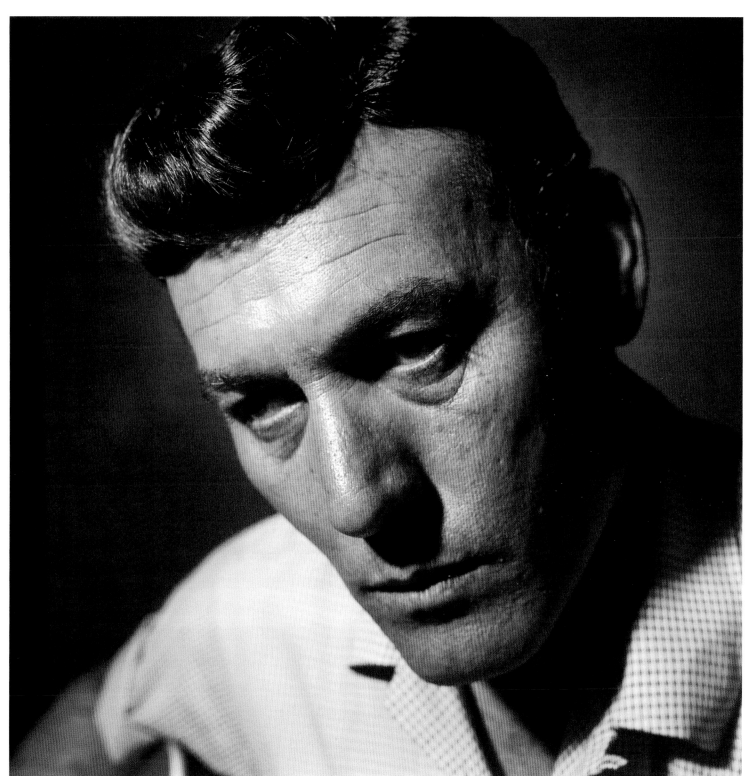
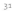

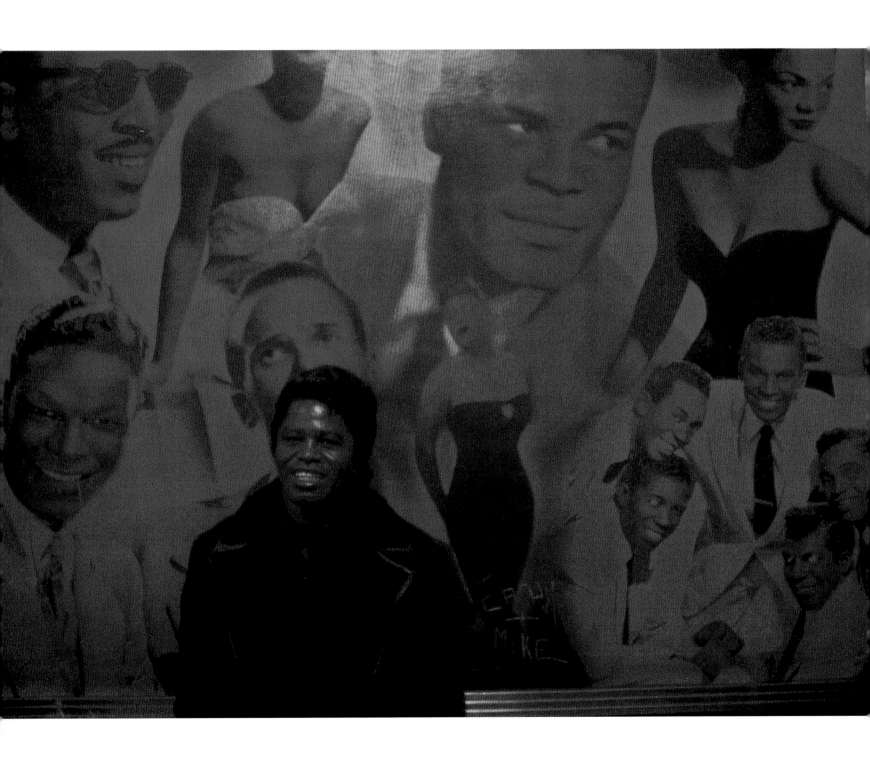

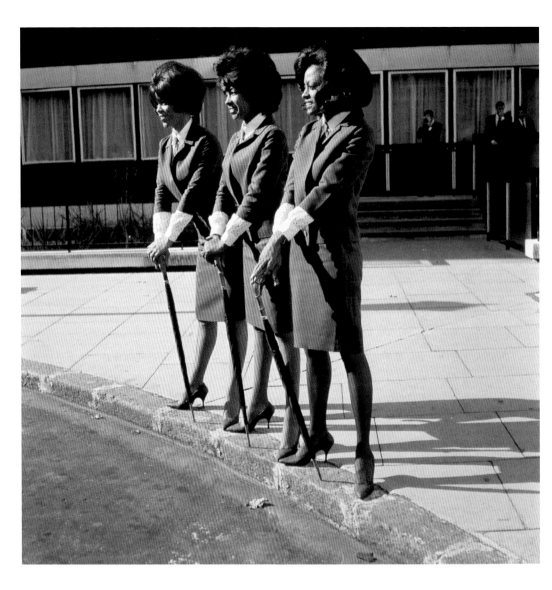

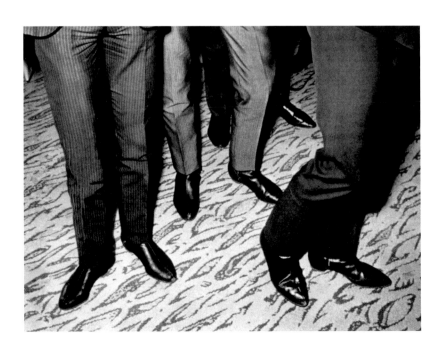

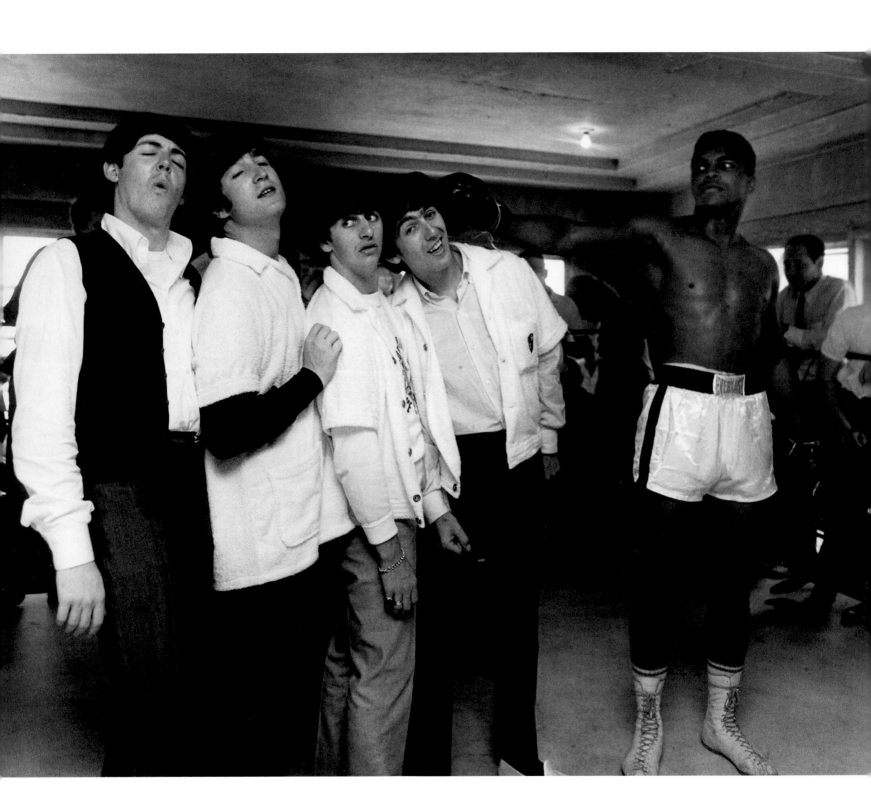

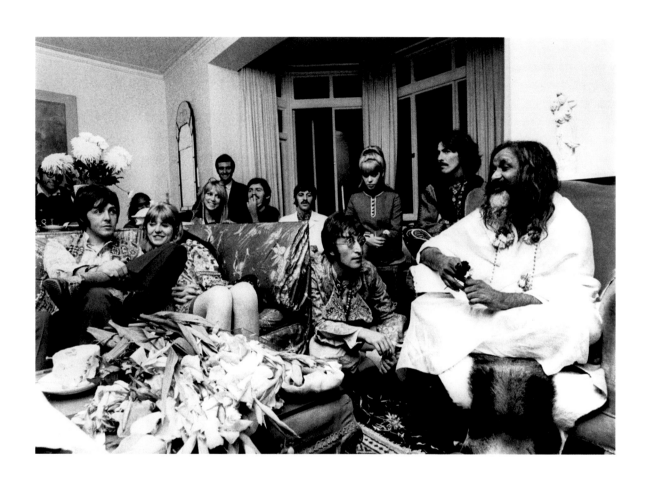

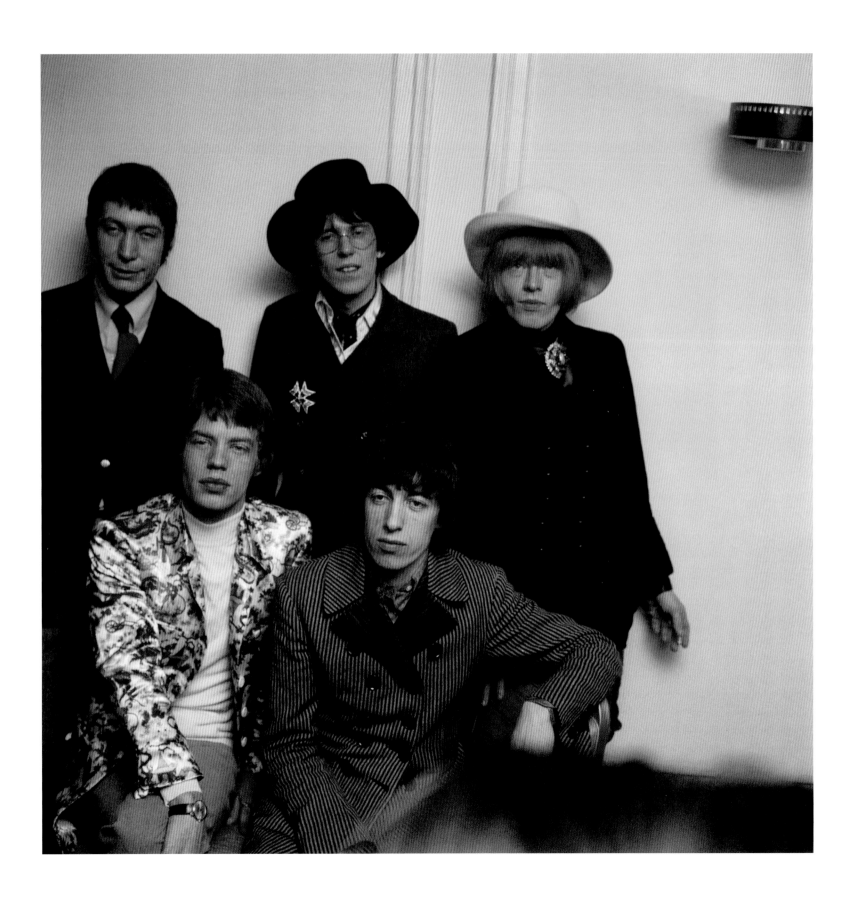

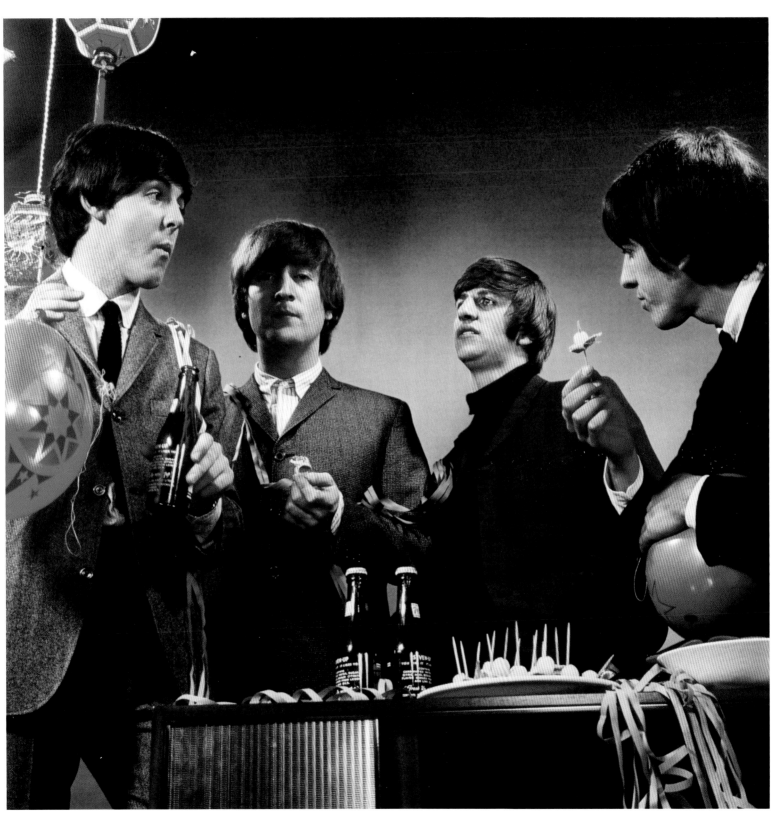

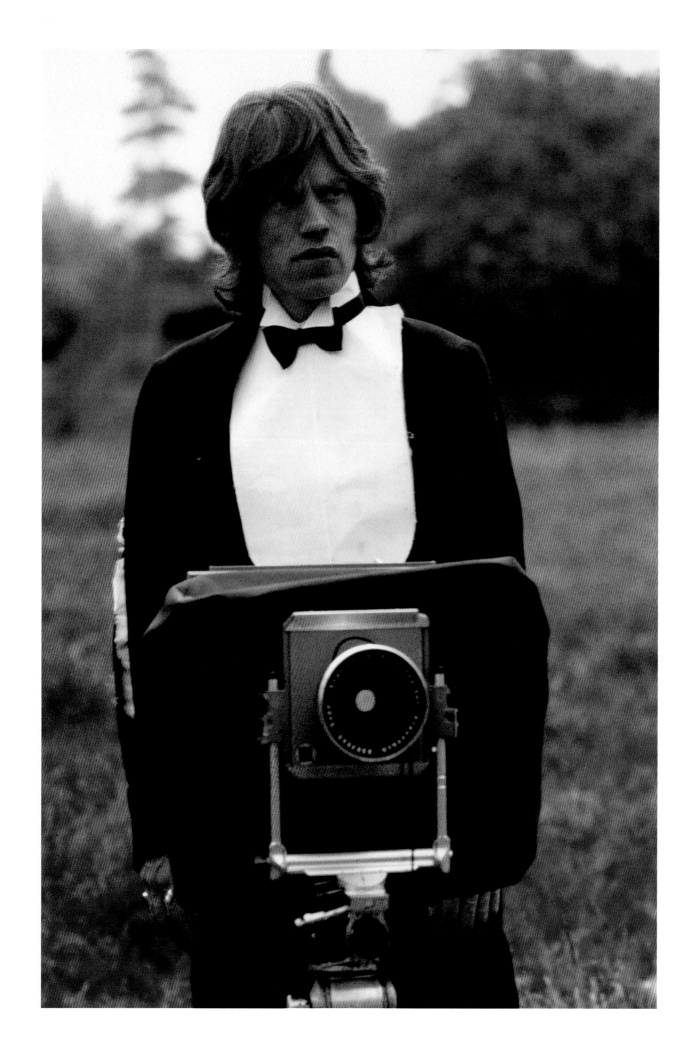

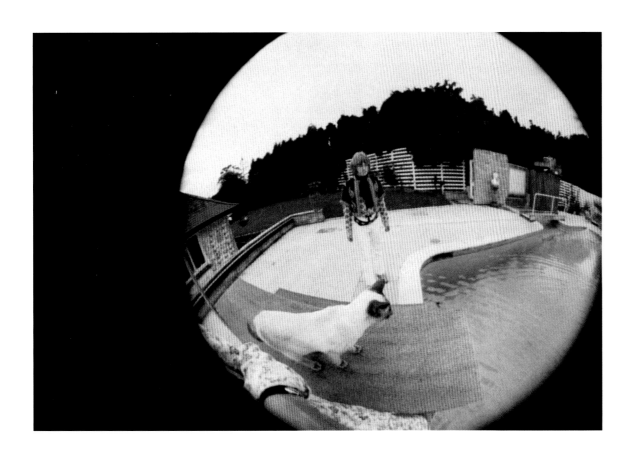

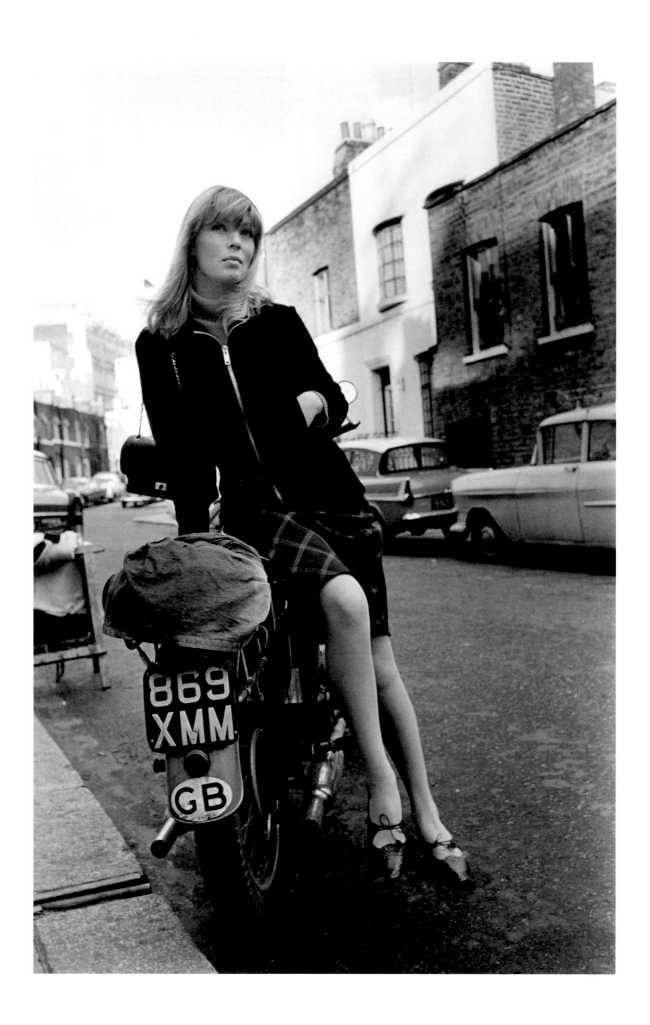

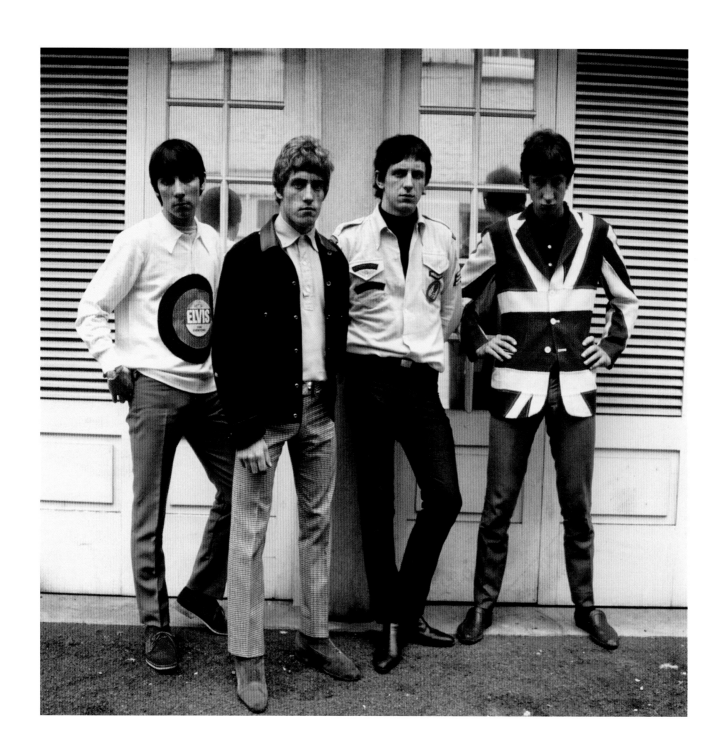

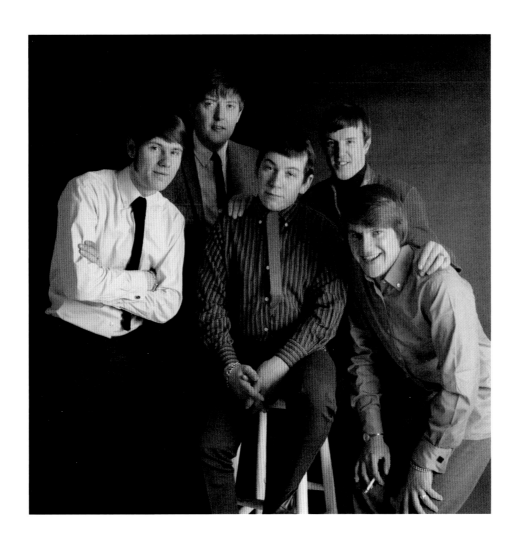

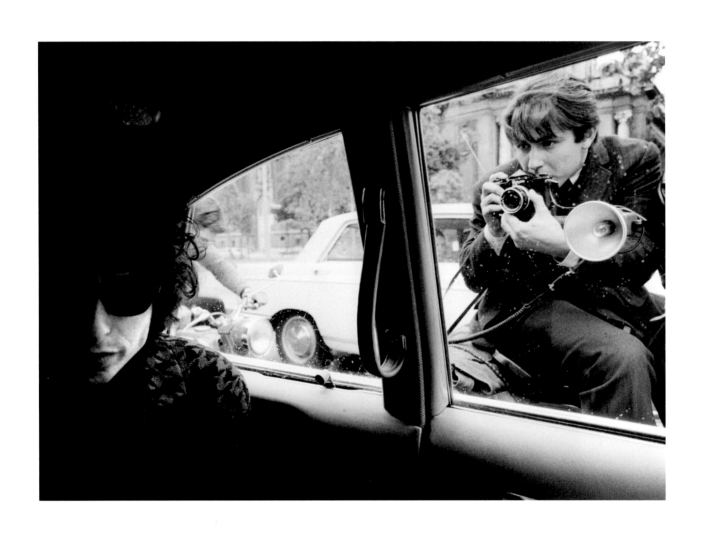

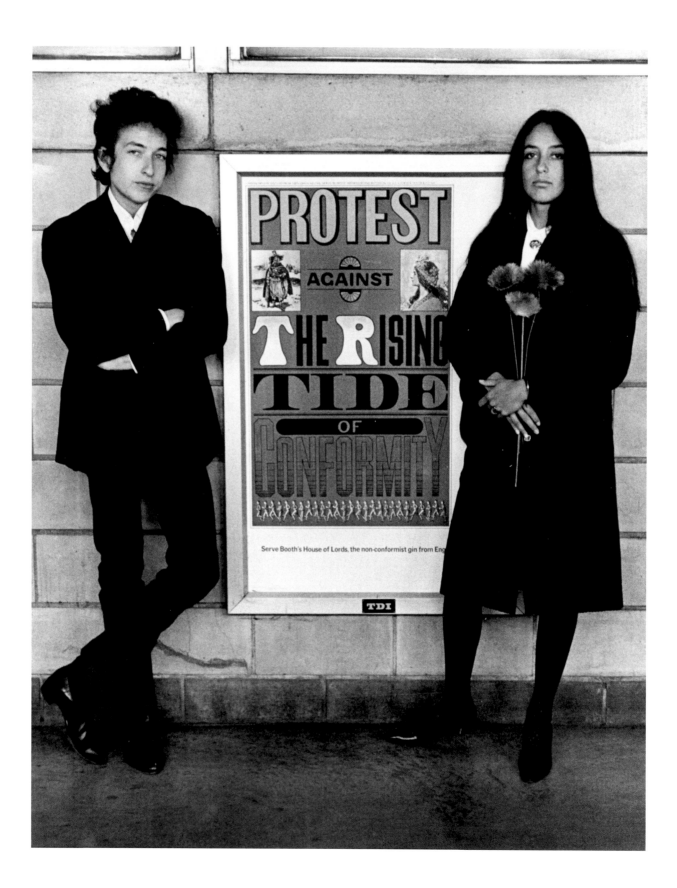

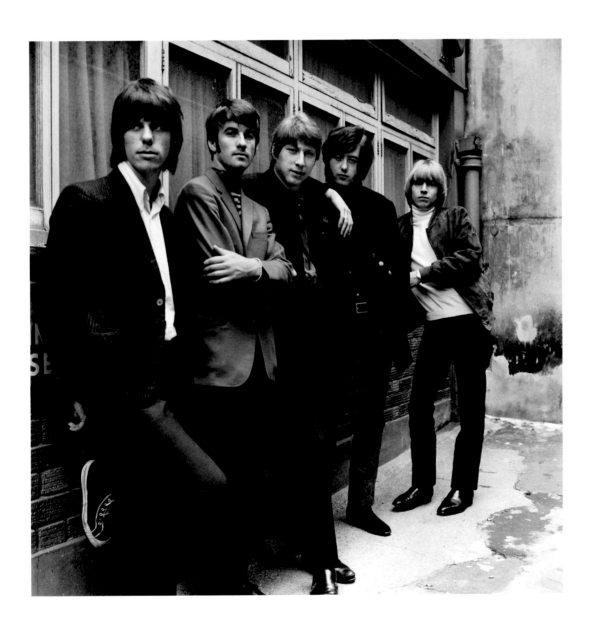

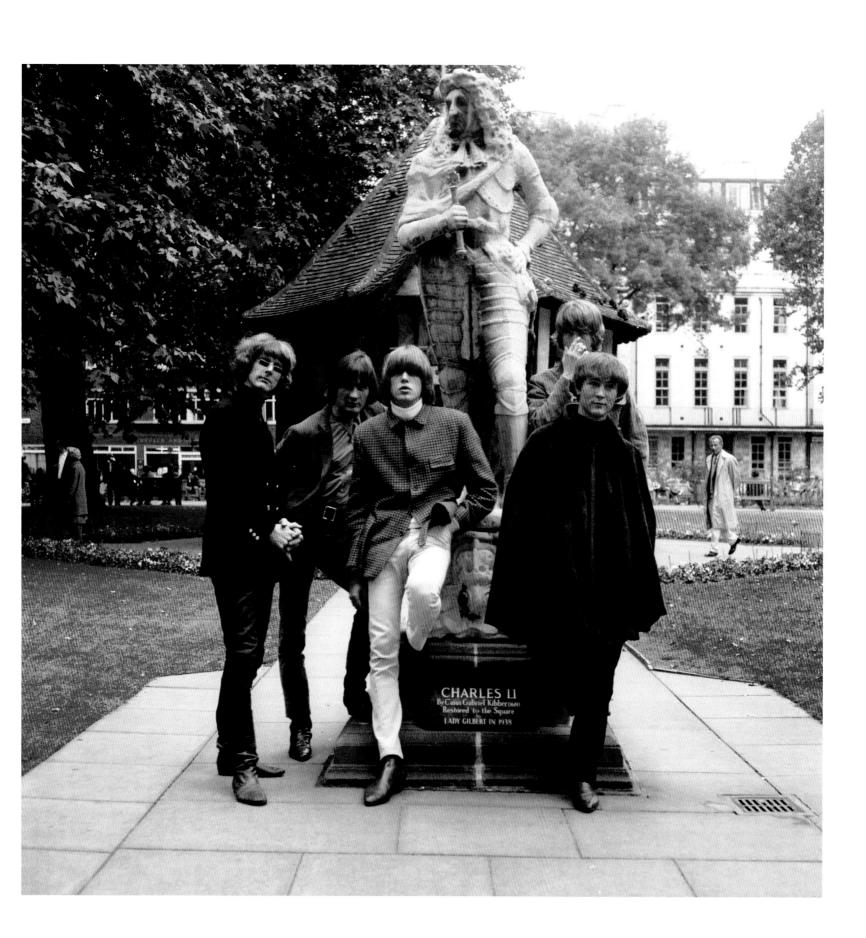

New York at Night Laura Levine

I stopped shooting musicians fifteen years ago. It was 1994. I spent a lovely day taking portraits of Nick Cave, put down my camera, and walked away. Up to that moment I assumed I would be working with musicians forever. But the fact is much had changed in the music industry over the years I'd been a photographer. Too many people were controlling access to the artists, insisting on approval of images, and focusing more on the clothing the musicians were wearing than on the artists themselves. What started out as a fun, spontaneous, intimate, and creative collaboration between two artists ended up becoming more akin to a marketing session. So I left.

It was a great run. From 1980 to 1994, I was one of a handful of photographers documenting New York City's music scene intensively, intimately, and from a true insider's perspective. Over that period I photographed more than five hundred bands and musicians—obscure to superstar, middle American to British, punk, New Wave, No Wave, hip-hop, indie, and "college radio"—most of them when they were just starting out or getting their first taste of success. I realize now how fortunate I was—and how much it was of a time and place and age (1980s, downtown Manhattan, we were all in our early twenties).

Although my focus was on people who created music, my intention was not to take rock photographs, but strong, intimate photographs—portraits that would stand on their own merit. I doubt it would be possible today to have the same access to and personal relationship with musicians that I had back then. Too much has changed in the music industry and media. Even the technology—film—is practically obsolete today. I can't stress enough how thankful I am that I made these photos on photographic film (as opposed to digital cards) and can create beautiful, warm gelatin silver prints from the original negatives to this day.

Let me backtrack to where I started. I had not thought much about photography until I saw the Diane Arbus retrospective at the Museum of Modern Art when I was fourteen. I walked away thinking, "I want to do that." I started out as a street photographer and then photojournalist. Growing up in New York's Chinatown, I took my first photography class, as a teenager, at the Henry Street Settlement and spent my afternoons after school wandering around my neighborhood in the Lower East Side, shooting street scenes and people. By the time I entered Harvard in the mid-seventies, I knew I wanted to be a photojournalist, and while in college I was the photo editor of the Harvard Crimson, did a summer internship at the Washington Post, and was a campus stringer for UPI and Newsweek. After graduation I got an internship at the Village Voice under the legendary photographer/photo editor Fred McDarrah, who was a great teacher and mentor. Although I'd always been a music lover, sneaking my camera into concerts since I was in high school, it was while at the Voice that I decided to narrow my focus as a freelance photographer to music. I was interested in combining my two loves—music and photography—and having majored in cultural anthropology in college, applying a documentary approach to the burgeoning underground music scene.

My days and nights were typical of the other photographers covering New York's music scene at that time—and there were only a few of us. I'd ride my bike over to a club and shoot the band onstage and backstage, stay out till the club closed at 4 a.m., ride back home to my Chinatown apartment (by the way, there's nothing more exhilarating than speeding down a deserted Park Avenue at 4 a.m. on a bicycle, catching the green lights all the way down). Then, bursting with adrenaline and because I simply couldn't wait to see how the photos turned out (did I get that one shot I think I got?), I'd get out the metal reels and film cans, mix up chemicals, develop film at 5 a.m., get some sleep while the film dried, get up a few hours later to make the contact sheets in the makeshift darkroom that my dad had built for me (no running water, no ventilation), and finally, see what was there. Then print, dry, and bike up to the Voice or the Times or whomever had assigned the story to me, to deliver the prints (the Times would develop the film for me, which was quite a luxury). When I shot bands on my own, without an assignment, I tried to interest various magazines in running the images. With a little pushing I'd get my photos into the pages of that month's Trouser Press or Creem or Rolling Stone.

One night I'd shot pictures of Debbie Harry and Chris Stein onstage with James Chance. The next day I showed the photos to a photographer friend whom I ran into on the First Avenue bus. He suggested I take them over to the New York Rocker, an underground music paper. I did, and within a few months I became not only their chief photographer, but I was also put on salary as their photo editor. (I remember the salary clearly—$50 a month; then again, my rent was only $350 a month at the time.) Rocker was on the second floor of a commercial loft building on lower Fifth Avenue—a few battered metal desks, a stereo that was always on, tons of posters, and a few ratty sofas. As a freelance photographer, you're always on the move, but being a member of the editorial staff meant I had a home base, and at the risk of sounding corny, I was part of a family. Once a month we would stay up all night pasting the issue together, using X-Acto blades and melted wax. Danceteria was around the corner, so most nights we'd all troop over there after work and stay till closing. We always got in for free, thanks to the kind doormen and club owners. (That was a perk of being part of the music press— free admission and unlimited drink tickets.) I pretty much lived there and at the Mudd Club, Tier 3, CBGB's, Peppermint Lounge, Hurrah, and Maxwell's.

My time at the Rocker pulled me even deeper into the underground music scene. The other source of my musical education came from my position as the U.S. staff photographer for the British music paper Sounds. They teamed me up with a young writer named Tim Sommer, and he and I traveled the country covering bands for stories to be sent back to England—British bands making their first visit to the States, Noise bands, No Wave bands, Punk bands. I was the beneficiary of my partner's deep knowledge about bands I hadn't a clue about, but I caught on fast. Because we were usually doing cover stories for Sounds, we were given total access to our story subjects. For example, when the Clash played their famous ten-night stand at Bond's in 1981, we were there almost every night, backstage, onstage, on the roof doing a private session with them.

Many sessions grew out of my personal relationships with musicians. I had passionate musical tastes and not only pursued shooting certain musicians on my own when they came to town, but I met bands through other bands. For instance, my friend Peter Holsapple from the dB's first told me about R.E.M. while handing me their homemade Radio Free Europe cassette at our weekly poker game. R.E.M.'s Michael Stipe, who became a great friend, introduced me to his sister's band, Oh-OK, and the other Athens bands. Through the Dream Syndicate (who ended up stranded in a blizzard and crashing on my floor the night I met them), I met most of the other Los Angeles–based Paisley Underground bands.

As a photographer, my goal was to connect to my subject. Working to get beyond the public persona of an artist, I tried to show the real person behind the image, to depict him or her in a private and intimate light, one that was rarely captured on film. I suppose that's what drew me to photography, and to musicians in particular; it gave me an opportunity to meet people I admired and respected, to get to know them on a more personal level, and to communicate to the world what I felt and saw through my portraits of them. My philosophy when shooting a portrait was to always stay true to the subject, and my rules were simple: be as natural as possible, don't impose an artificial fashion or style on the subject, collaborate and let the subject's true nature shine through.

Separating race from rock & roll is like removing salt from seawater. Thomas Denenberg

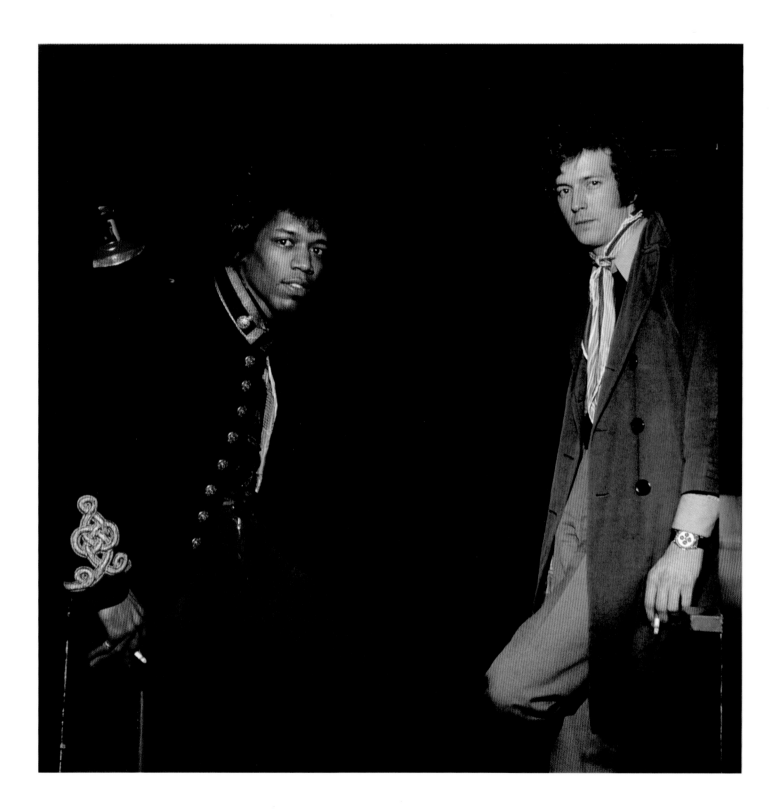

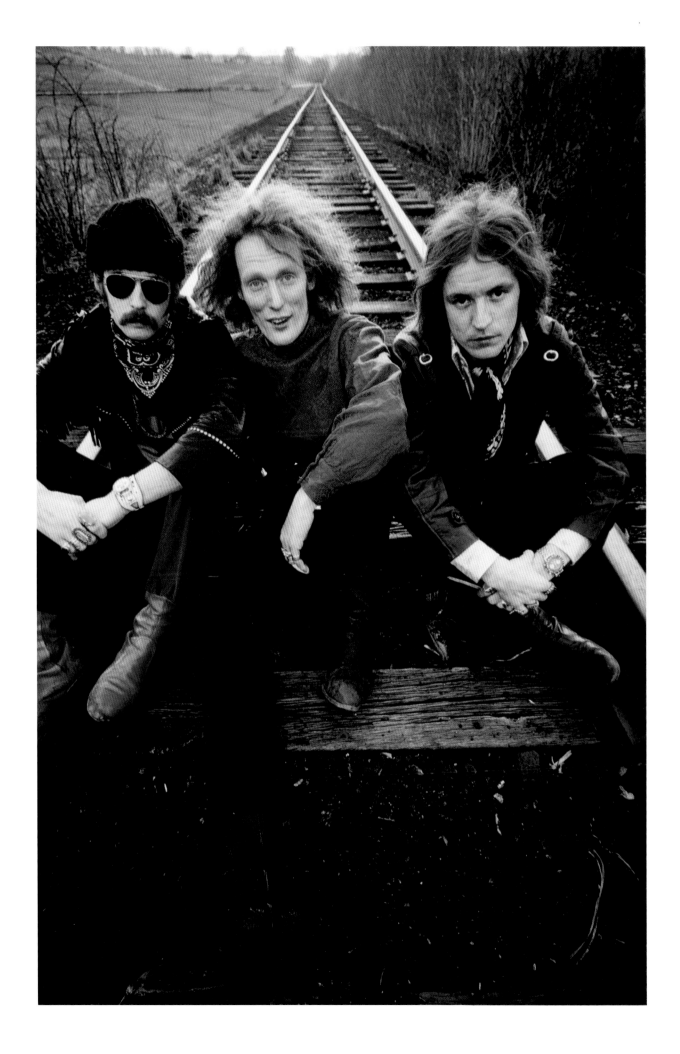

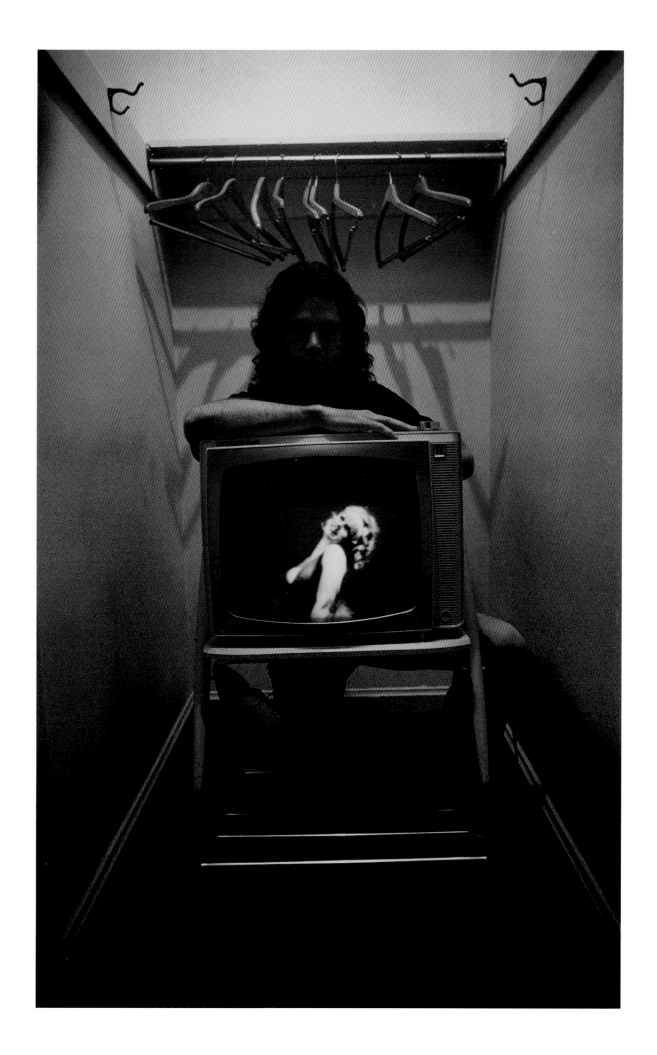

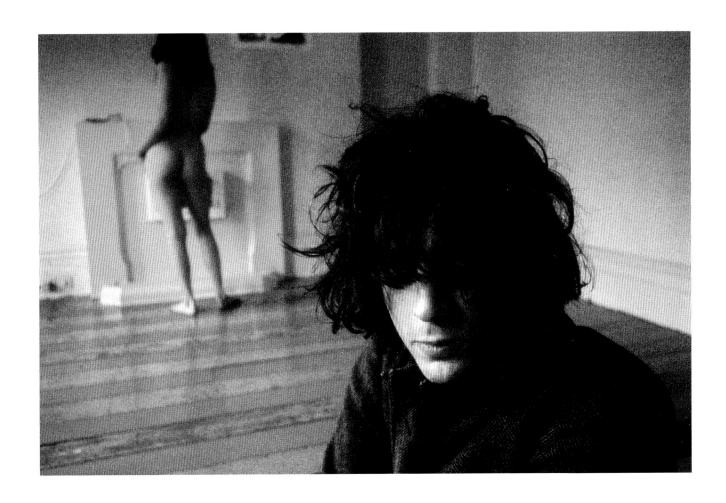

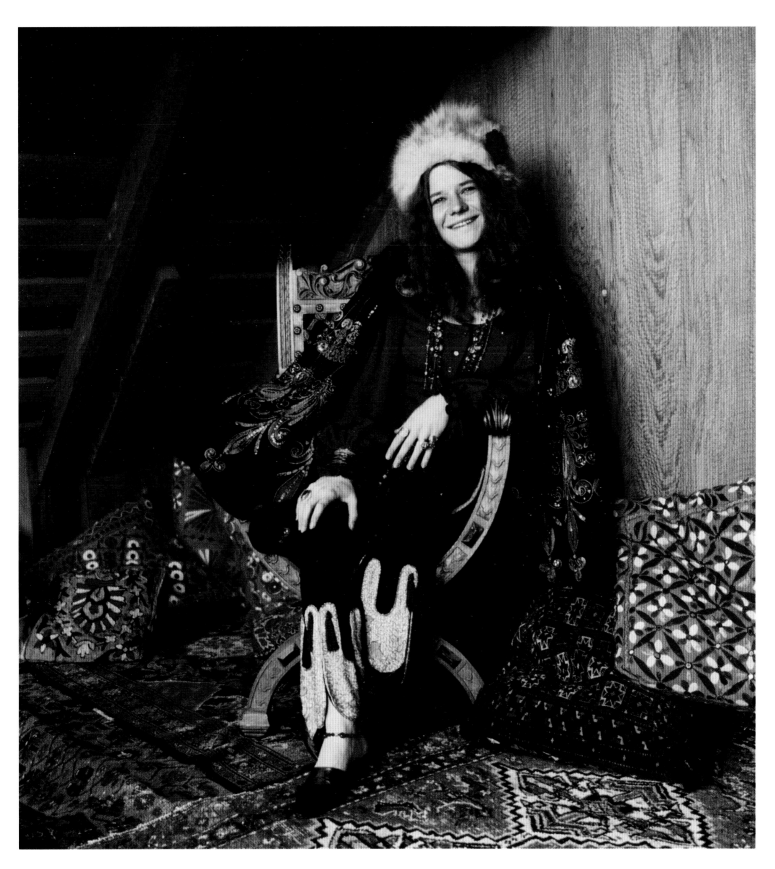

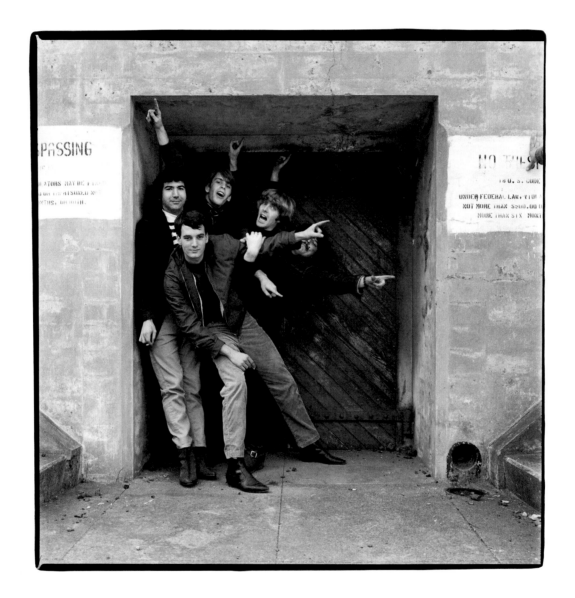

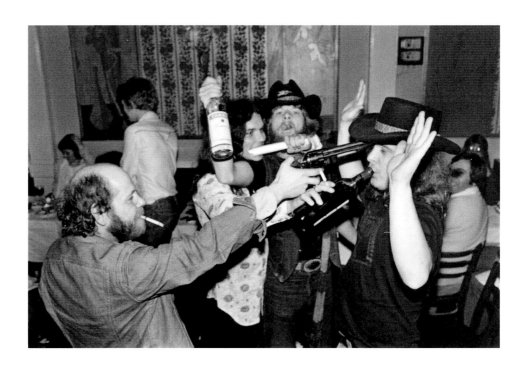

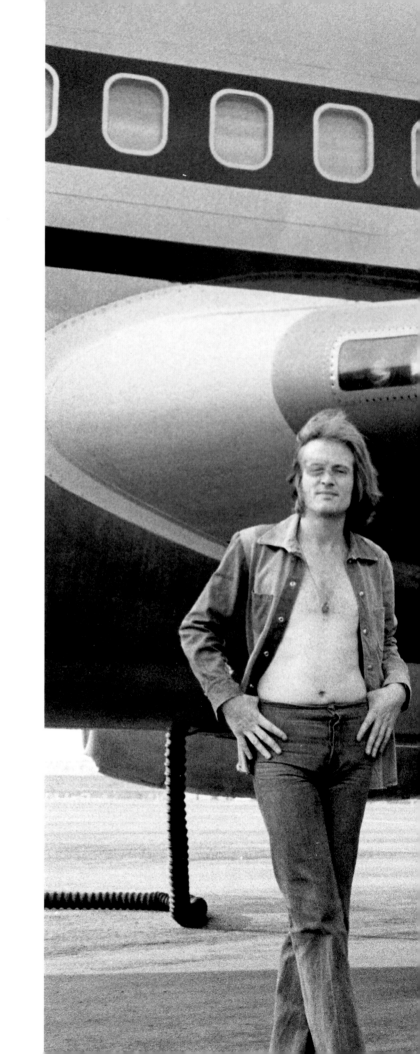

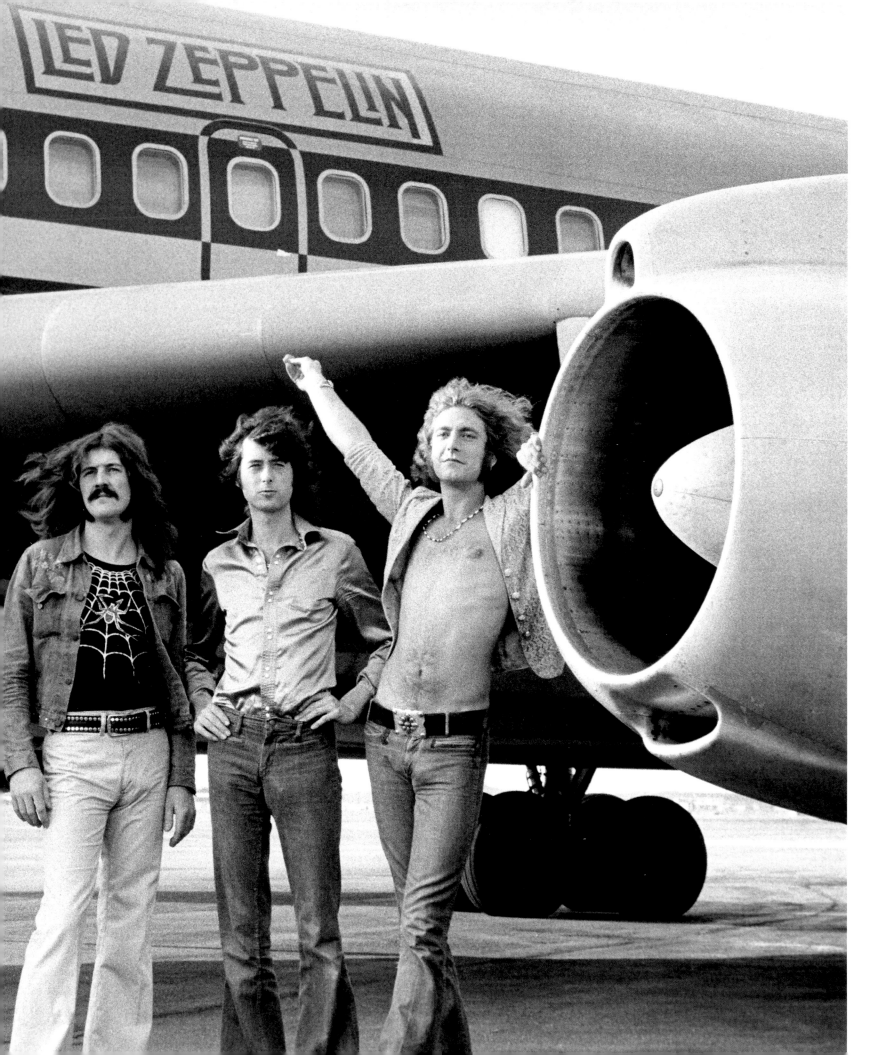

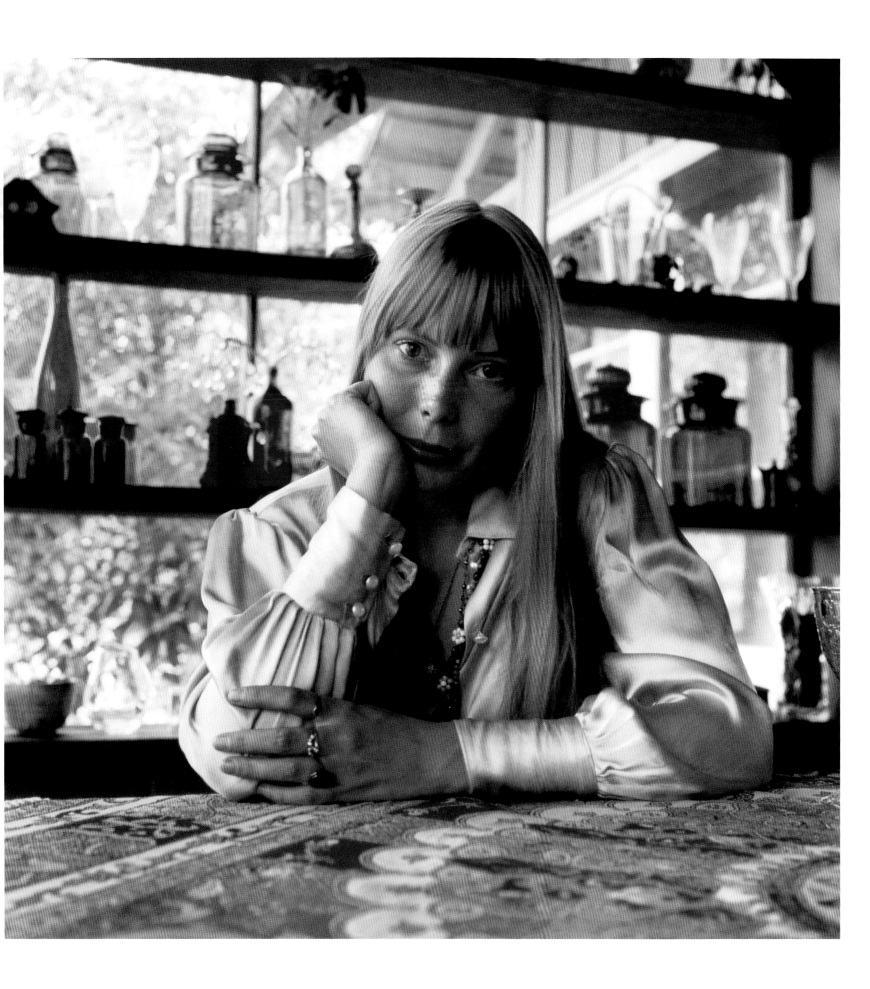

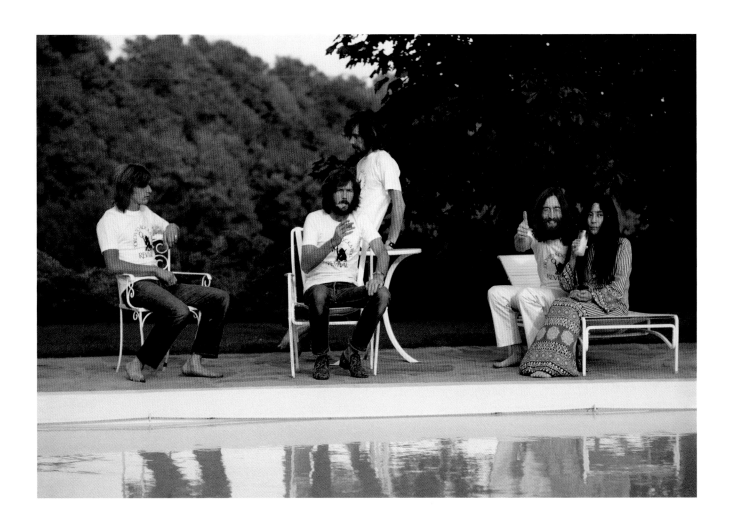

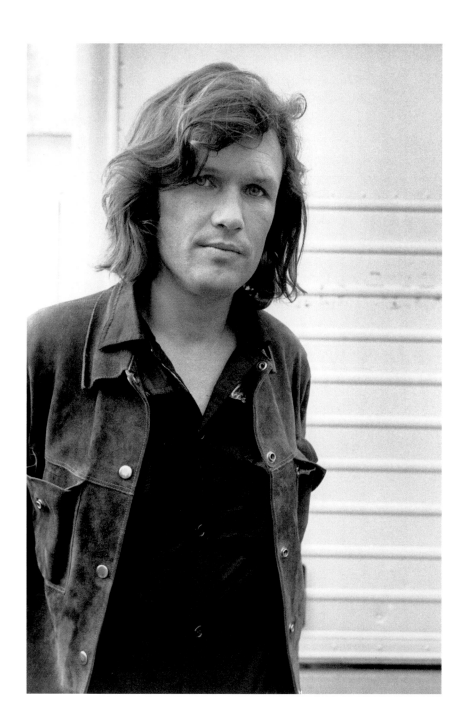

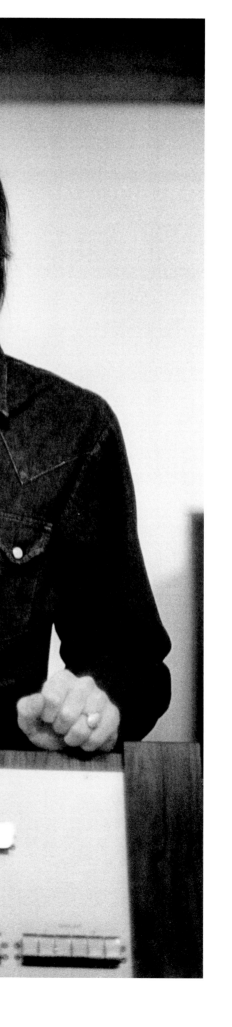

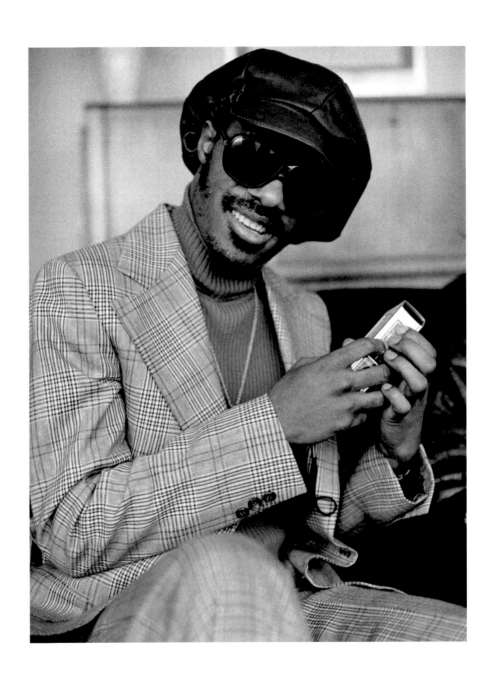

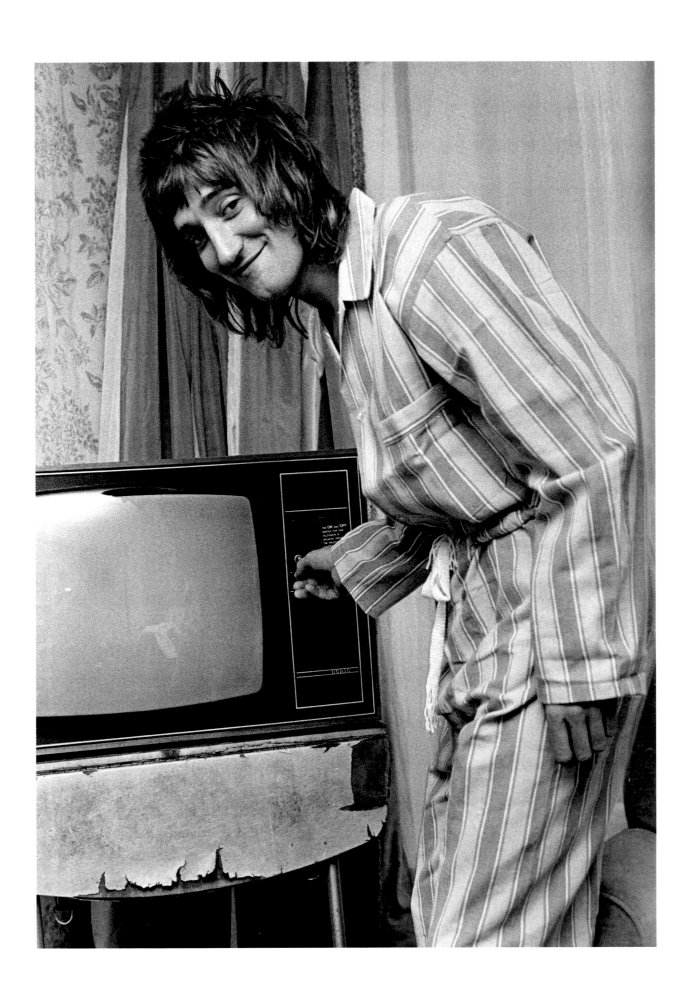

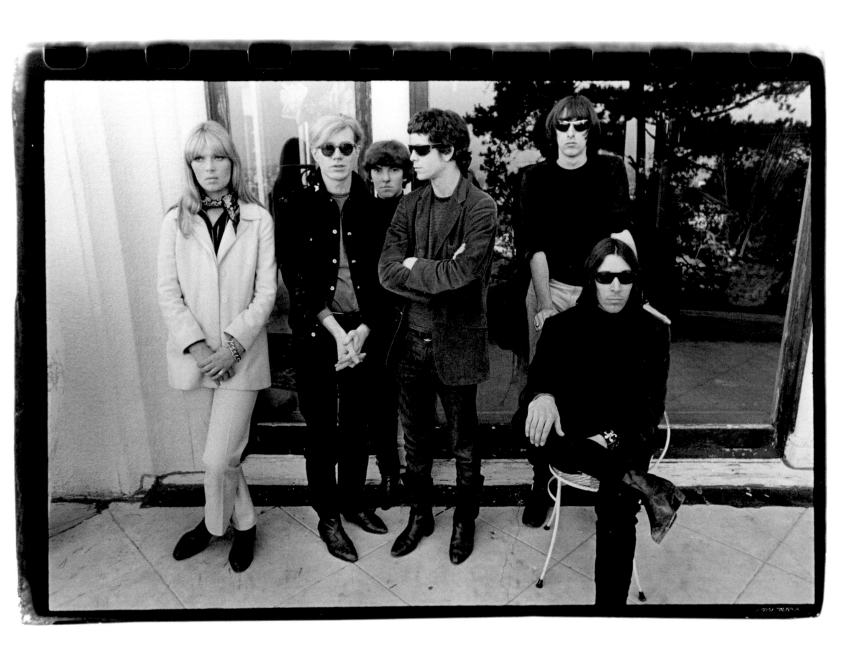

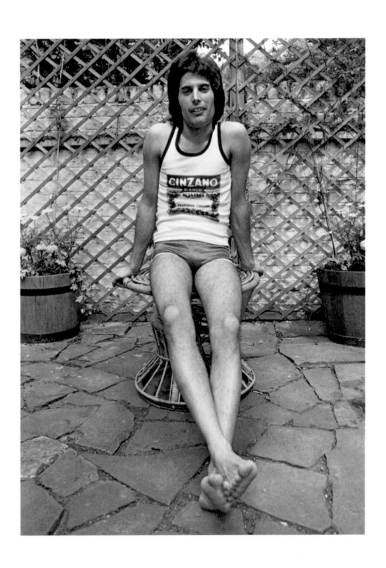

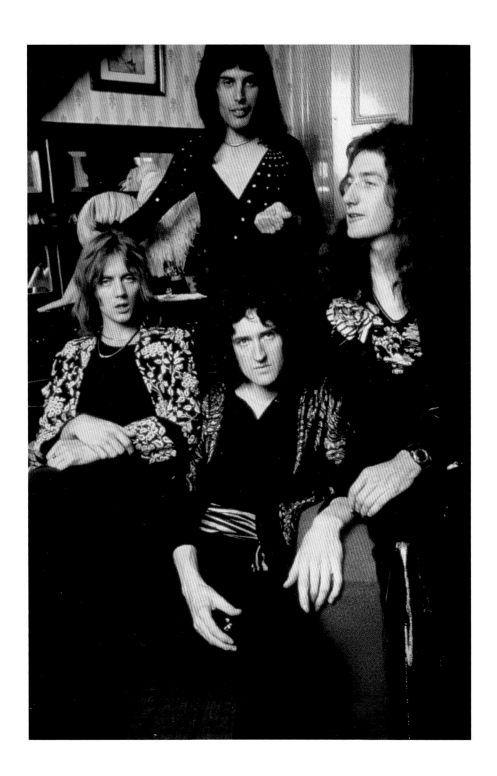

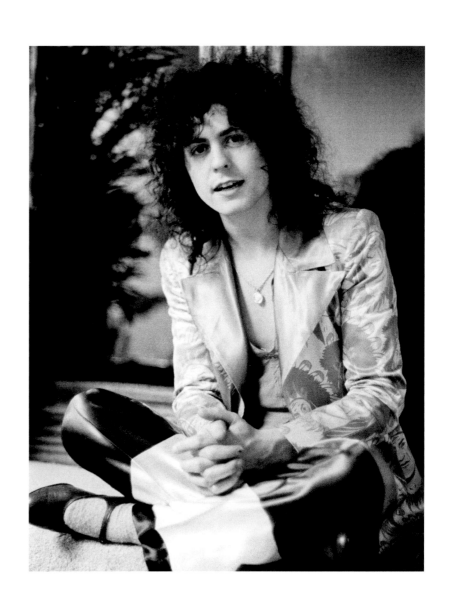

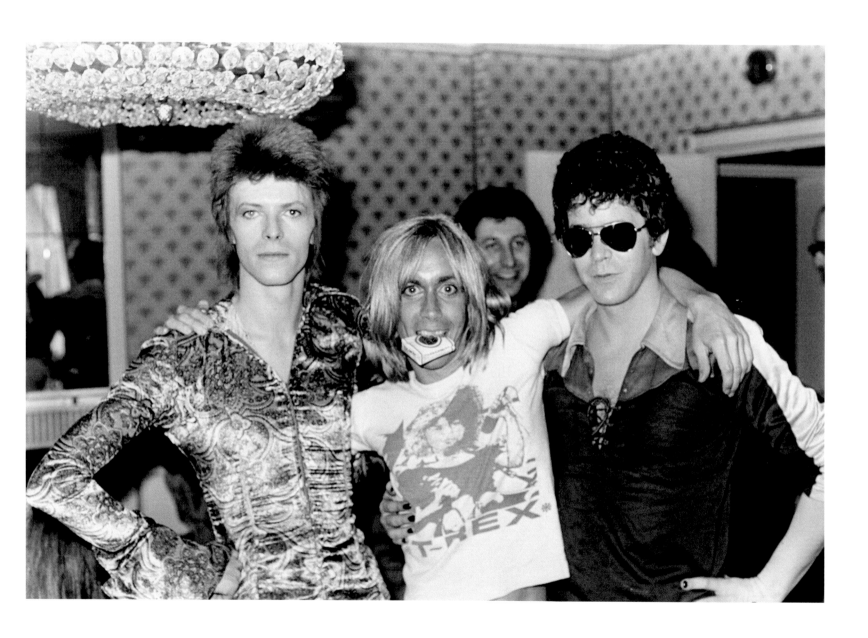

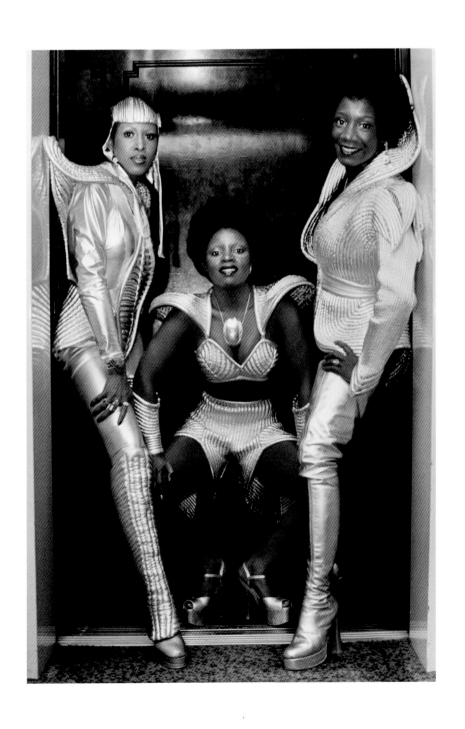

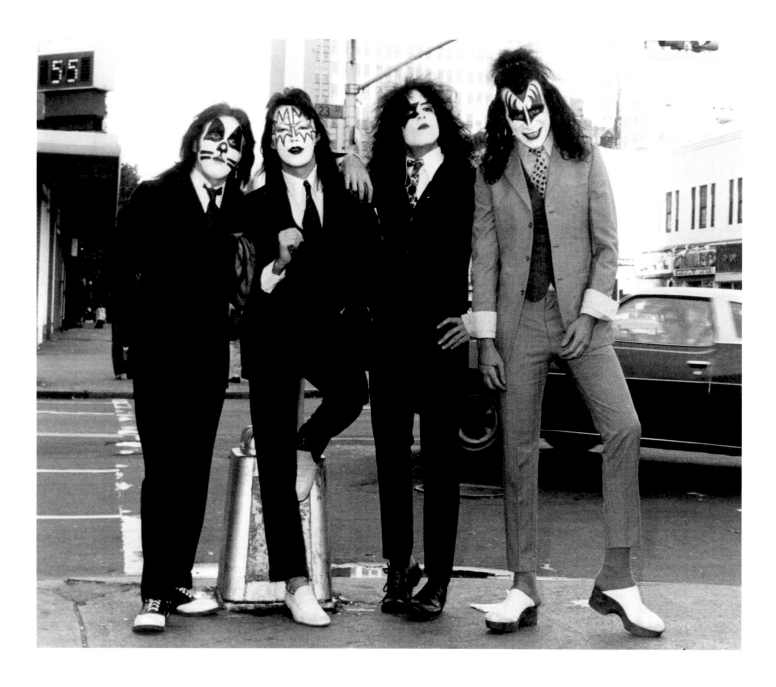

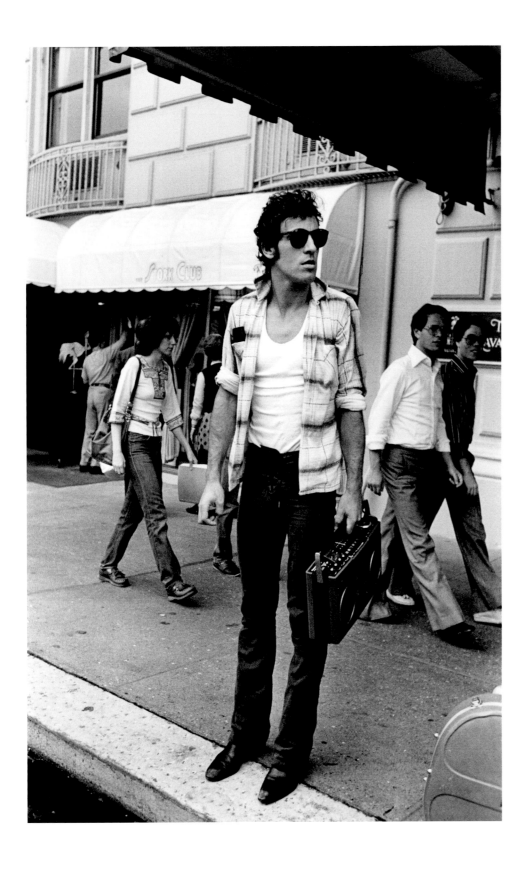

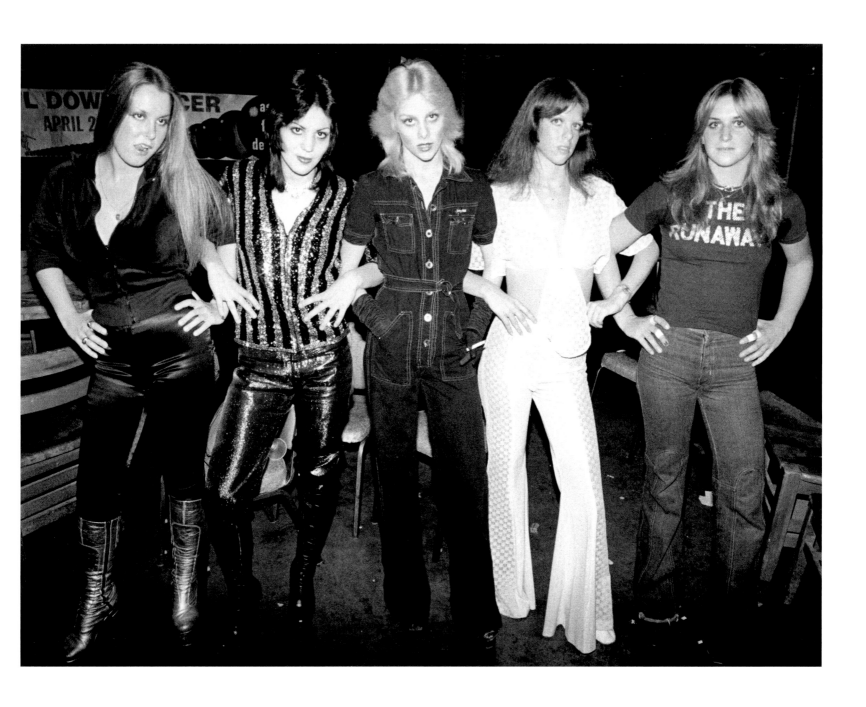

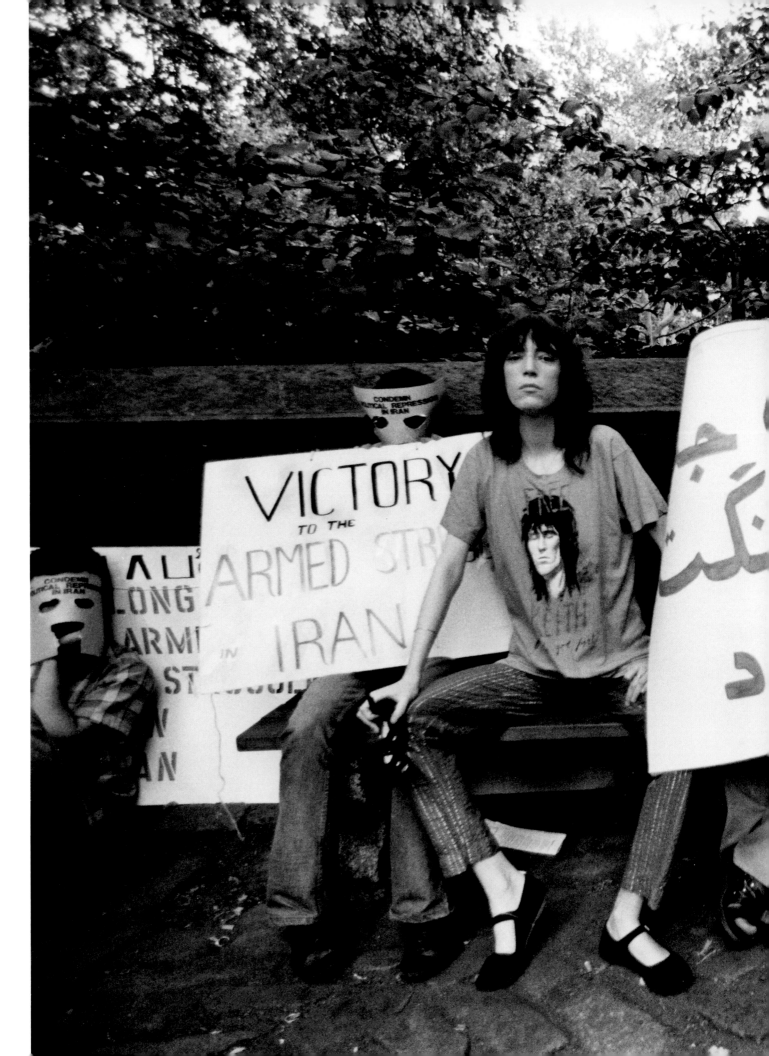

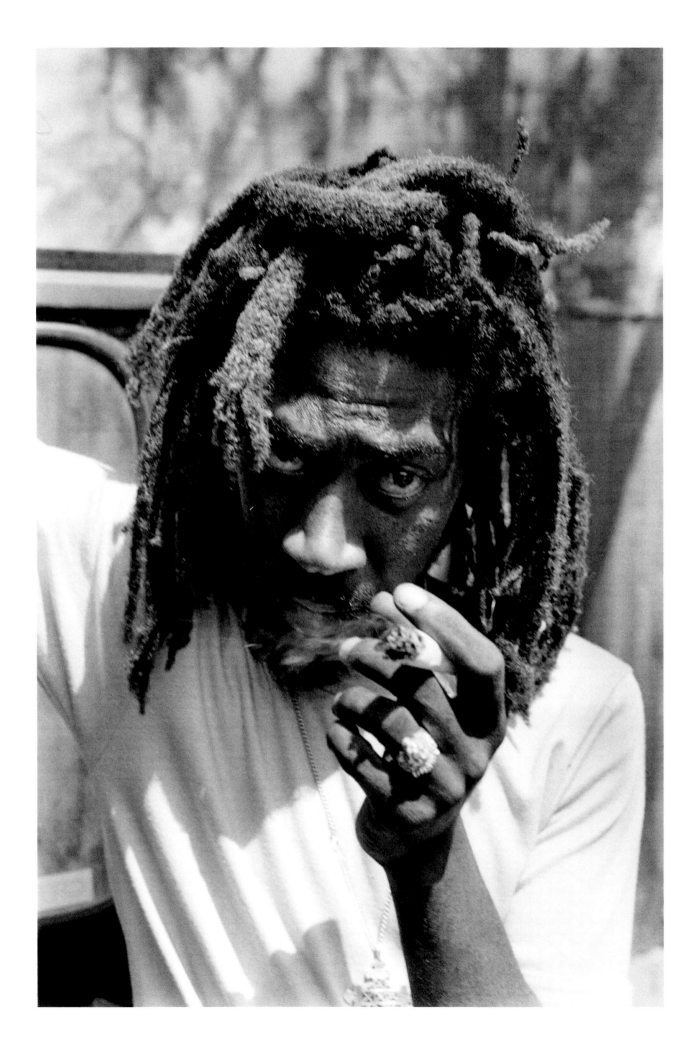

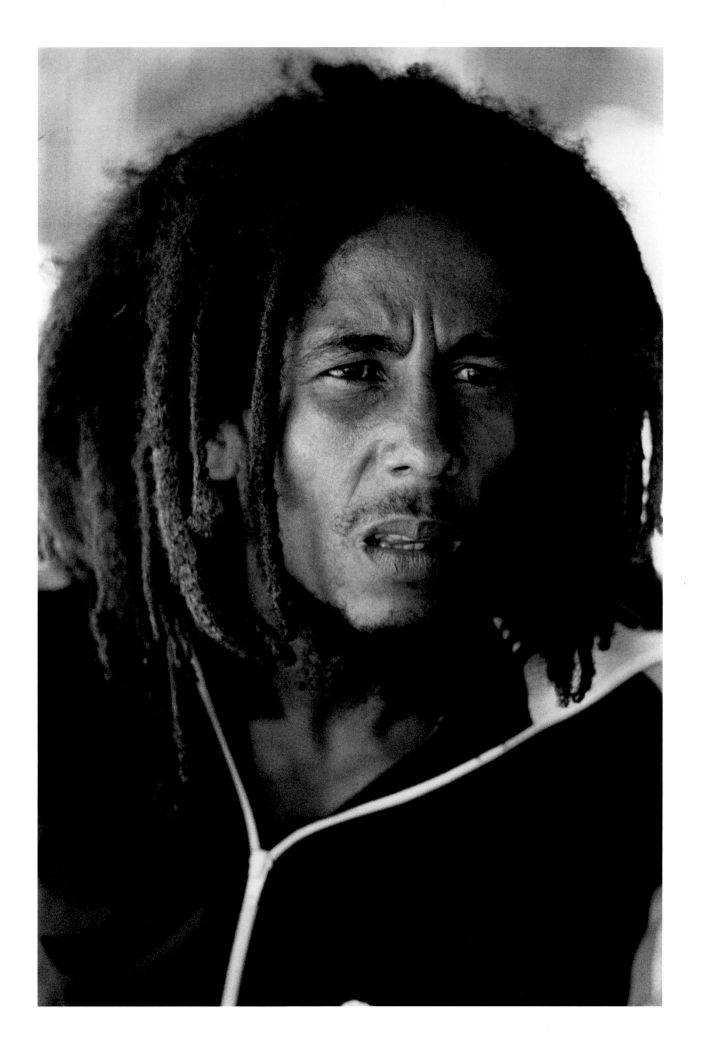

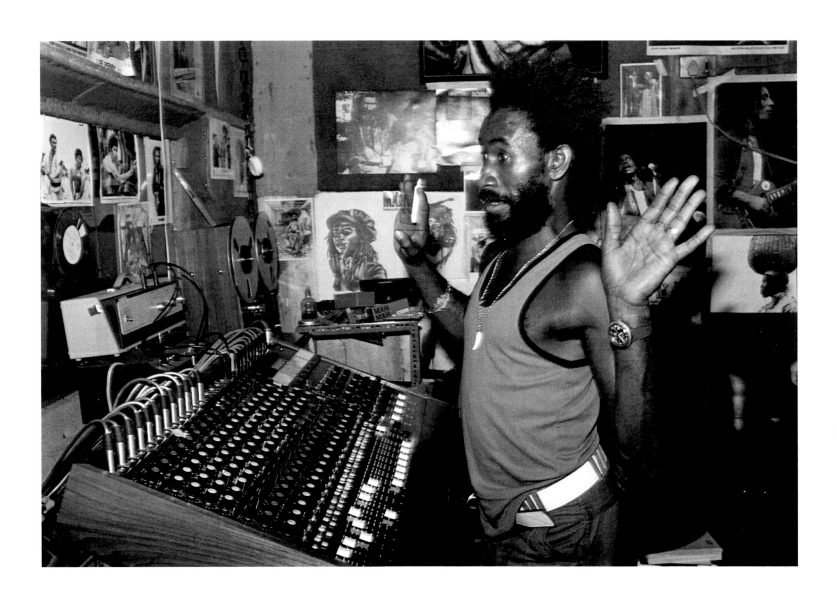

Eye Contact and the Ear Glenn O'Brien

Some people collect string. Some collect comic books, postage stamps, steel wool, art, or photographs. Lots of people collect something. It's a default hobby. But true collecting, the activity that makes one "a collector," is not incidental or casual; it is obsessive and compulsive. It's about collecting what you love or what you are inexplicably taken with. What you must have. What you might steal if you couldn't afford it.

Most art crimes involve perfectly respectable people who are suddenly discovered to have been stealing things for years. The collector understands them. A true collection is magical; it's something that speaks to you in the night. It's something that is part of you. Not just a bunch of things that give momentary diversion, but things that somehow, through processes both psychological and magical, both logical and mysterious, give meaning, excitement, pleasure, and even power to the collector. Collecting is love of material things. But at the highest level, it's spiritual. It's about the soul of the object; the residual life in it. The thing collected is a gris-gris or a mojo. It has magic for the collector.

It is specificity that makes a true collection. Specificity bordering on obsession. A true collection is inherently different from all other collections. Collecting has rules and conditions. Some of these are shared conventions, but the rules that make collecting interesting are the ones unique to a collection. Dabblers collect string, but real collectors collect red hemp string or prewar bakery string. Some people collect postage stamps, but others collect pre–Italian union postage from the Papal States. Some people collect photographs of popular musicians, while at least one I know collects photos of seminal popular musicians at the peaks of their careers, looking into the camera. Why? Collecting can be an art of its own. Decoding a collection is discovering what makes it an art form of its own. Joseph Cornell started out as a collector, and then the collection collected him. Collecting is not a rational thing. It partakes of compulsion, obsession, or a ritual or mania, and the things that constitute a great collection are profane fetishes, improvised jujus, and idiosyncratic talismans—objects that have a magical relationship with the collector. The only differences between a great collector and a person suffering from obsessive compulsive disorder are taste and money. The genuine collector has no choice in the matter. The collection chooses the collector. It whispers to his lobes like a demon or a god. The collection is a very specific externalization and objectification of the collector's personality and that inner voice, which is why great collections are so sharply focused and just plain peculiar. They come from the core of the character. They are more than symptomatic; they are defining and essential.

This photography collection was created out of love by a serious music lover, a man devoted to certain music and to the people who make it. At times the collector has been a mentor, producer, and/or enabler of some of the most important musicians of our time. Although he worked in the music business, his involvement wasn't really about business but about love—love of the artistry, the music, the performance. But the collector saw that show business was magic. It was redemptive. It was what Andy Warhol would call "business

art," a form of art that redeemed commerce, a form of commerce that redeemed art.

Before he became a collector, or before he knew he was a collector anyway, he collaborated with many artists with whom he had a deep affinity. It's not the usual motivation. It's like becoming a whore not for the money but for the love of the work. But I have always believed that the greatest work is done by amateurs, in the root sense of the word: lovers. This collector deeply loved the music and the musicians who made it.

This collection documents a collector's ardent and faithful love of the music and the artists through whom it has come. This collection is completely personal. It not only reflects the idiosyncrasies of refined individual taste and partisanship, it also has a sophisticated angle: "The majority of the photographs I have," says the collector, "possess two qualities. One, the musician is in his or her prime, and two, the musician is making eye contact."

It is about, as Doc Pomus put it in lyrics, "this magic moment." In the Jay and the Americans' song, the moment was when lips were in proximity, but here it is when the eyes meet. It is about that moment often sung of, when the singer sees "the love light" shining in the eyes of his beloved. To fully understand the implications in the context of modern sexuality, I would recommend listening at high volume to that great disco/funk song "Contact," by Edwin Starr: "I was looking at you. You were looking at me. We made eye-to-eye contact ..."

Everybody knows about the eyes being windows of the soul. George Bush said of his first meeting with Vladimir Putin: "I looked the man in the eye. I found him to be very straightforward and trustworthy ... I was able to get a sense of his soul." To many businessmen, a direct gaze signifies trust, openness, or confidence. But the eyes tell other stories as well. Eye contact with a bear means attack may follow. Eye contact with a Cree or Ojibway Indian means equal status is felt. In primates, eye contact evolved as a dominant and threatening mode. An FBI special agent once noted, "What gives police officers away in a roomful of people is their habit of looking too intently and too carefully at others."

In these photographs we can read the minds of the icons or catch our reflection in their mind's eye. We can meditate our way through the portals of their pupils, into something resembling touch. The eyes are the windows of the punk, too. A hatch into the head. A way into the way out. The camera won't steal your soul, as primitives are said to believe, especially if your soul is that of an inveterate poser. If anything, it may steal the soul of the beholder of the photograph. The facsimile eye is a representation, but it is also a two-way street. It gives the soul an escape route. The soul, under attack, can enter the camera and remain on film or chip indefinitely, until released again, genie-like, into the world of images, where it is free to enter another host. Anyone well versed in Hollywood's treatment of demonic possession should understand this principle. The stars possess us through the glance.

Keep in mind: these are performers, not the man on the street. These photographs may be candid, spontaneous, even a snap of a pop dervish or street shaman spinning out of control, but at the very same time, these are usually professionals at work. Being a shaman is a job, too. The subjects of these pictures are doing their job, and they know what they're doing. Professional posers at work; do not try this at home. This pose is as much a part of the act as is the sound. It's sound and vision. Like Bowie sang, "Don't you wonder sometimes, 'bout sound and vision." Video killed the radio star; that's evolution, not intelligent design.

It's ironic that during the punk period the worst thing a punk could say about a peer was that "he's a poser." (If you said "poseur," you weren't a punk, you were New Wave.) Punk is above all else a pose. But it is a brave pose, an almost ambitious pose. It is a pose that is adopted in the belief that the first step in becoming something is pretending to be it. The trappings and gestures are magical, and they somehow evoke the real thing. Once the pose becomes habit, it takes hold, it puts down roots. A lot of the rock stars you see here started out as fans and by imitating their own idols became idols themselves. And these photos were part of the metamorphic process. A pose is no good unless it is seen, and these are the poses that became realities.

The other prime directive of this collection, the other magical initiatory requisite of the collector, is that these are performers in their prime. At the top. Number one with a bullet. If not at the top of the charts, then at the top of their very refined and powerful game. There are few more extreme examples of evanescence than in pop stardom. It is truly here today, gone tomorrow. The extremely transient nature of success is part of the process we understand as stardom. They are always shooting stars, having meteoric careers. The twilight of our idols is tacitly accepted. They burn bright, then burn out. What does it all mean? The fate of stardom is worth pondering, as it is a key to what we call our culture. You'll never find it questioned in the media for that is its very mechanism. Perhaps it's a casual form of religion, this apotheosis of youth, a condition as unattainable as immortality. Perhaps it's a divide-and-conquer political structure, a matrix of permanent alienation, a continuous state of doomed revolution that serves the status quo. Whatever the cause of the temporal phenomenon that is stardom, peakness shows. It is palpable and deeply affecting and quintessentially romantic. There is some sadness in the contemplation of a frozen moment where one will never be better, but there is also joy and the knowledge that music is a time machine that always takes us where we want to go: now.

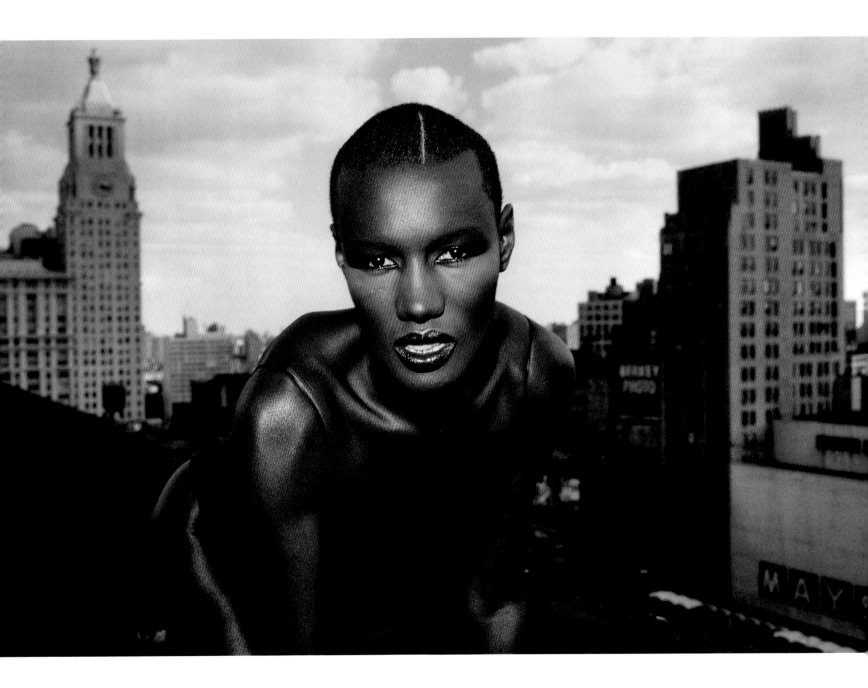

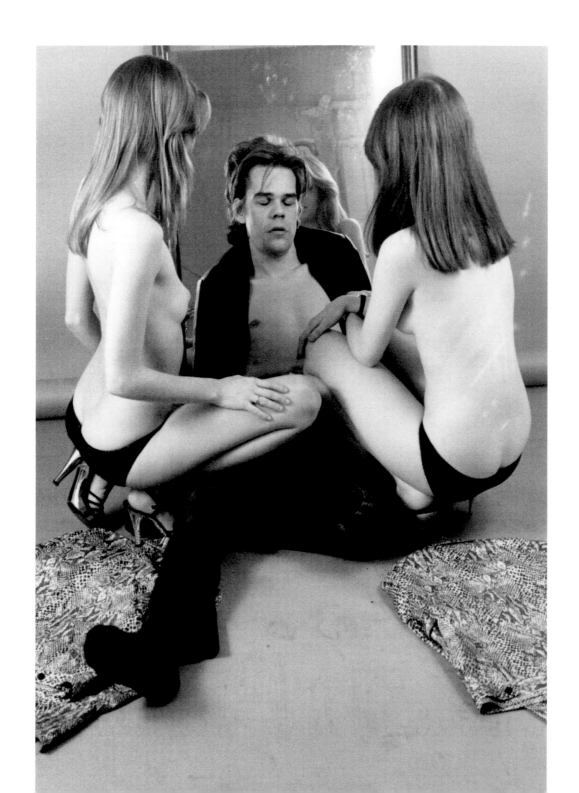

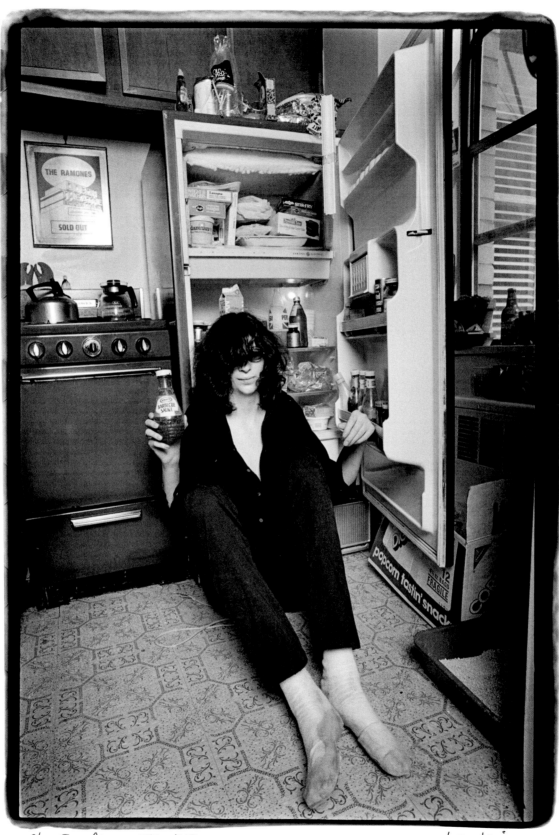

3/50 Joey Ramone, NYC, 1982 Laura Levine

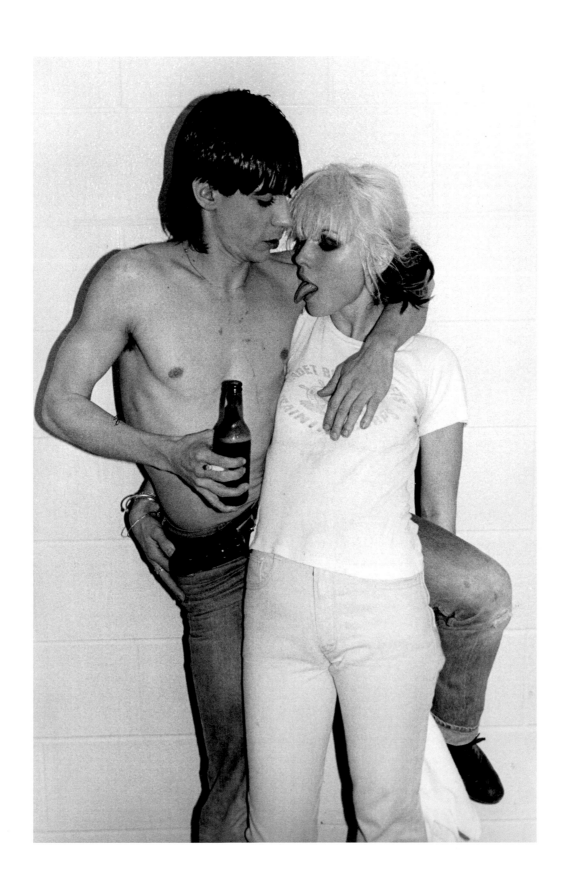

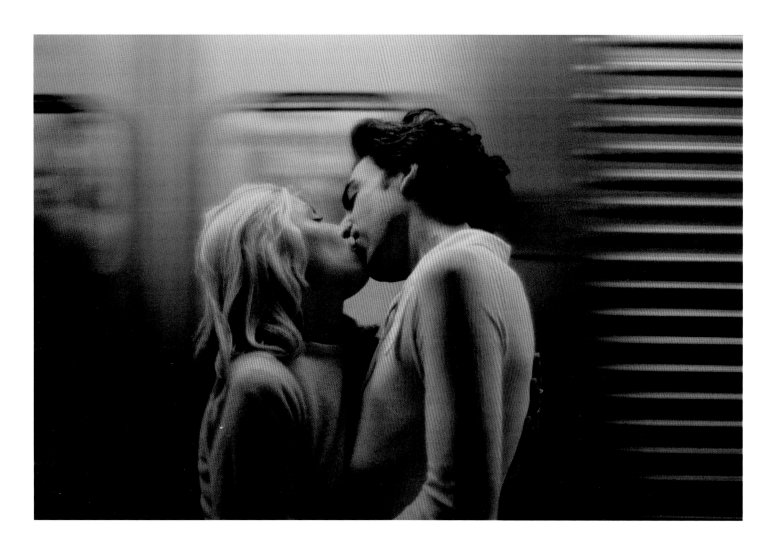

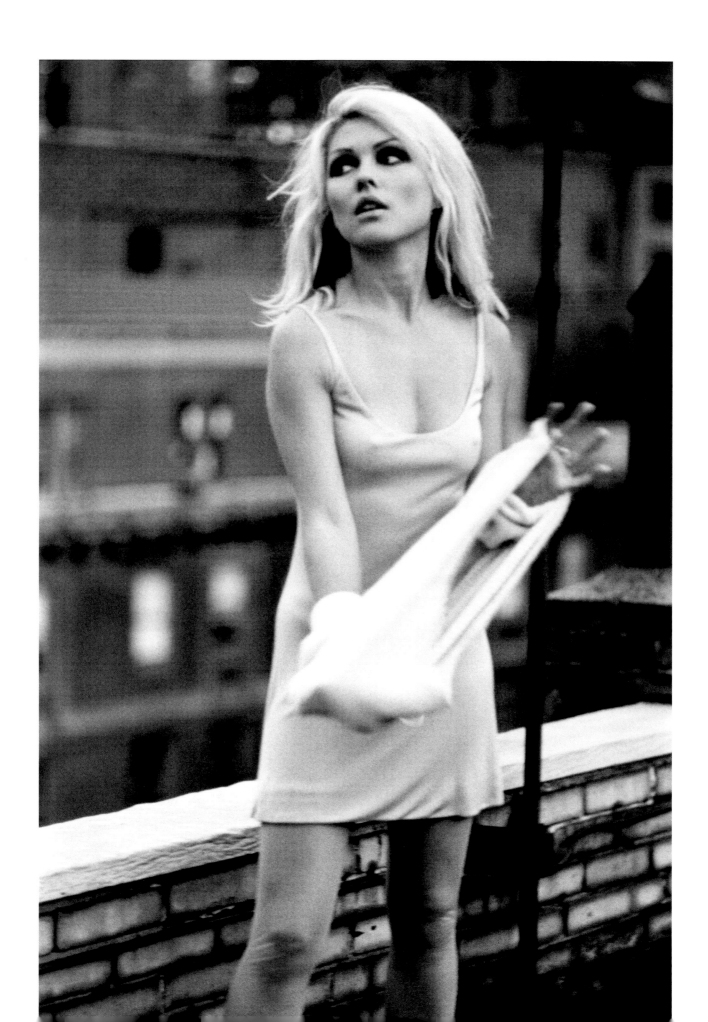

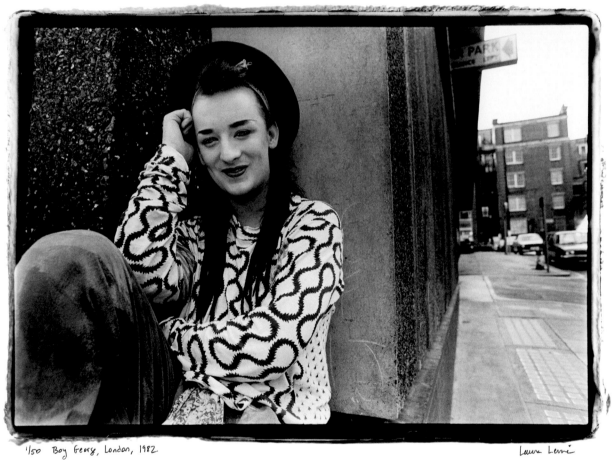

¹/50 Boy George, London, 1982 Laura Levine

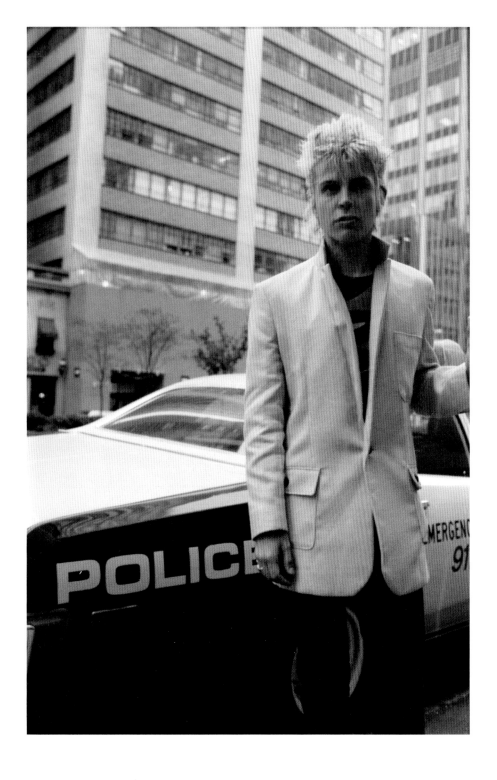

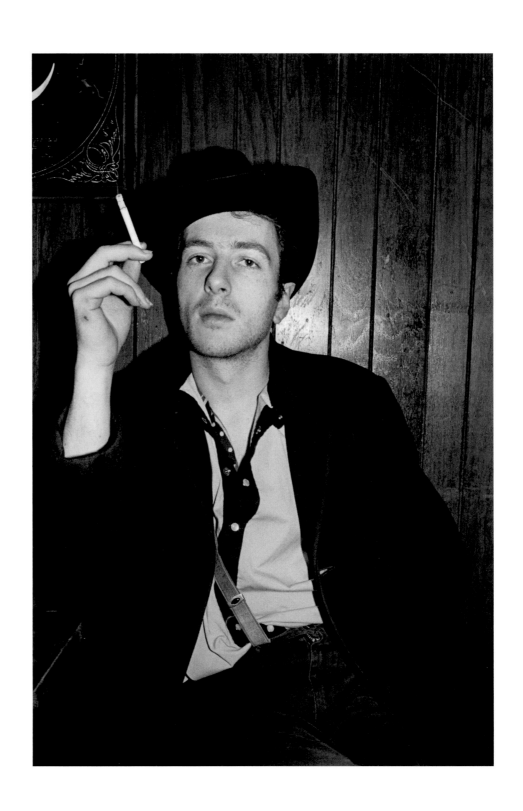

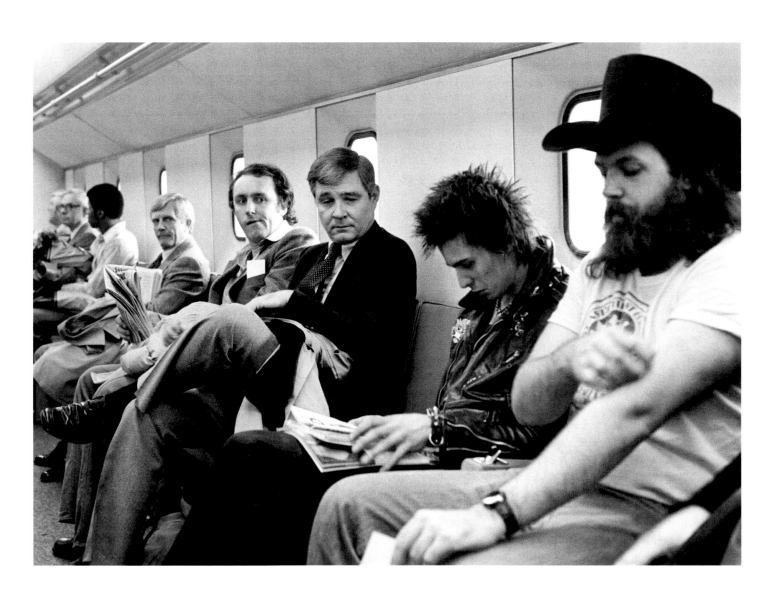

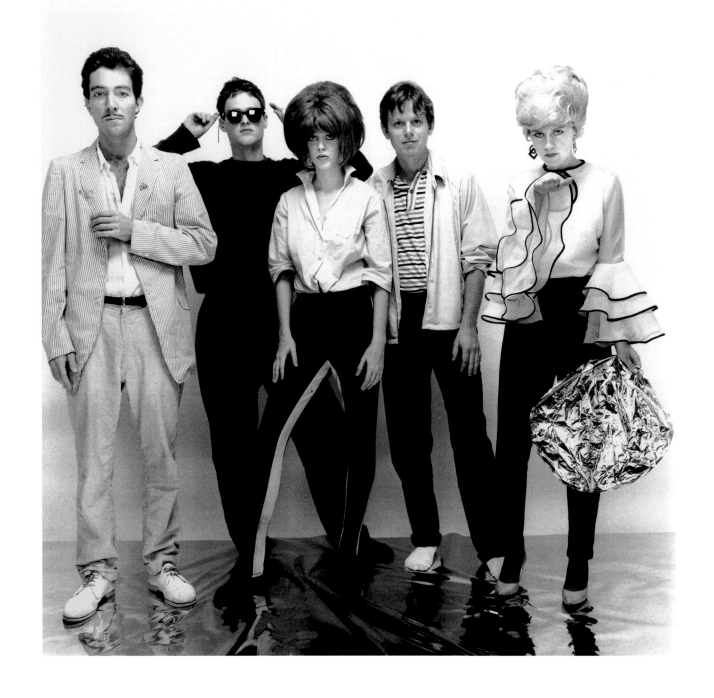

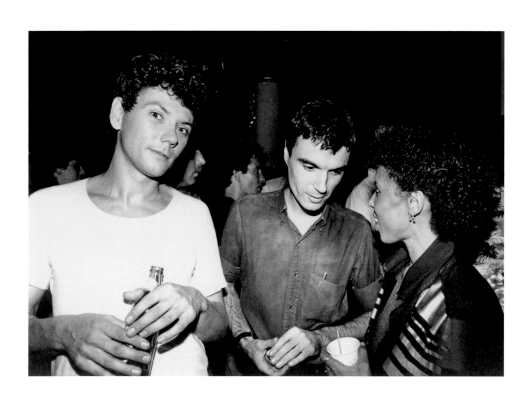

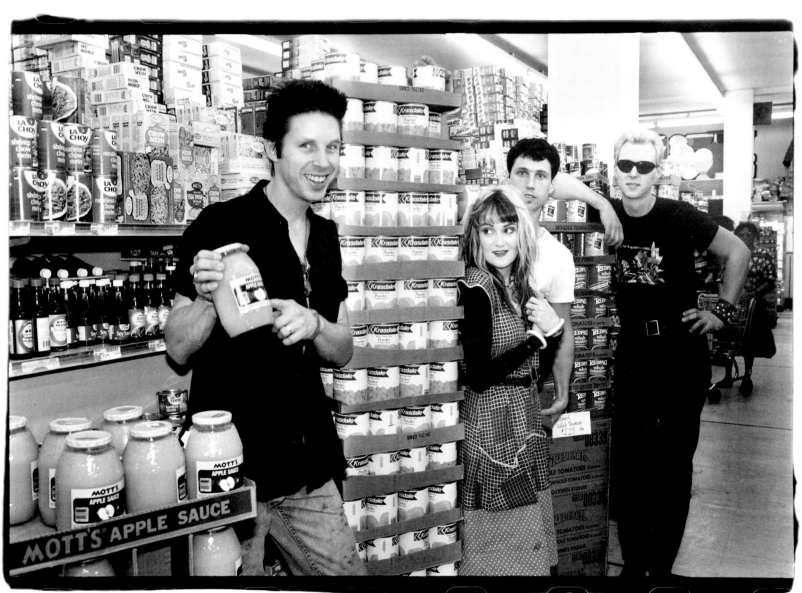

1/50 X, NYC, 1982 Laura Levine

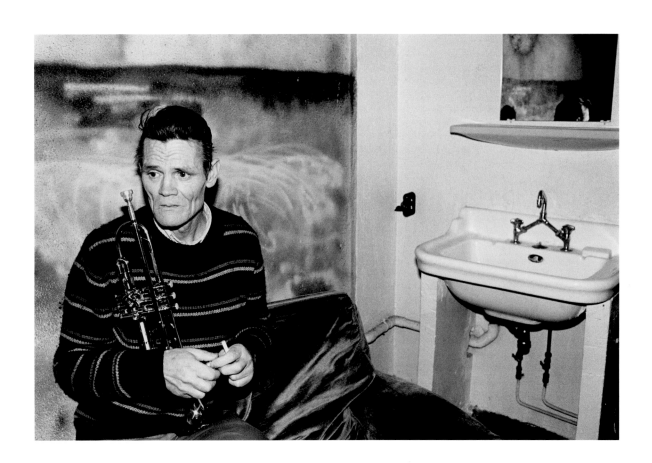

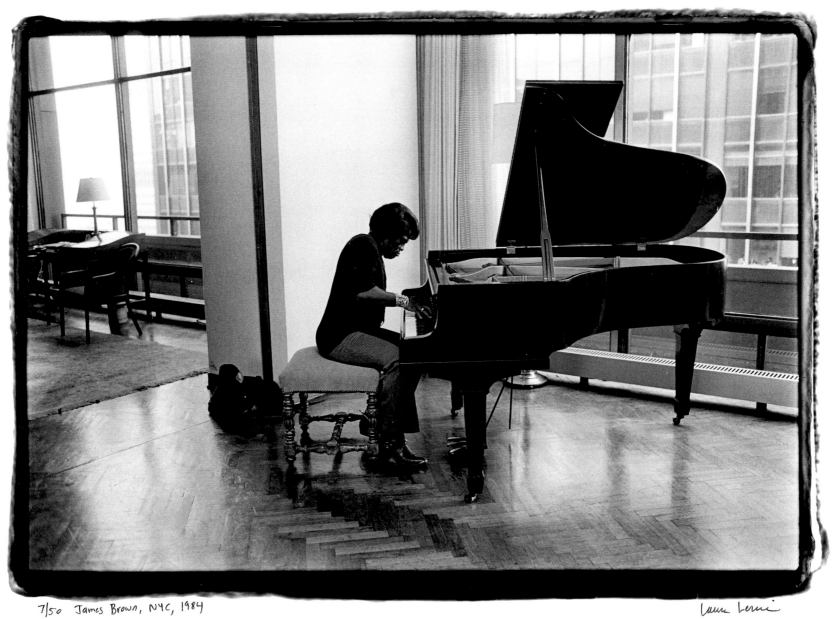

7/50 James Brown, NYC, 1984 Laura Levine

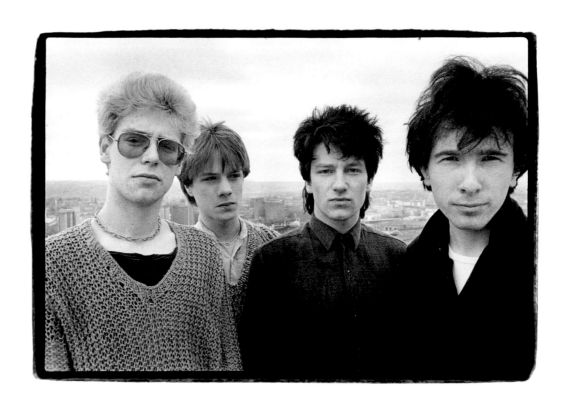

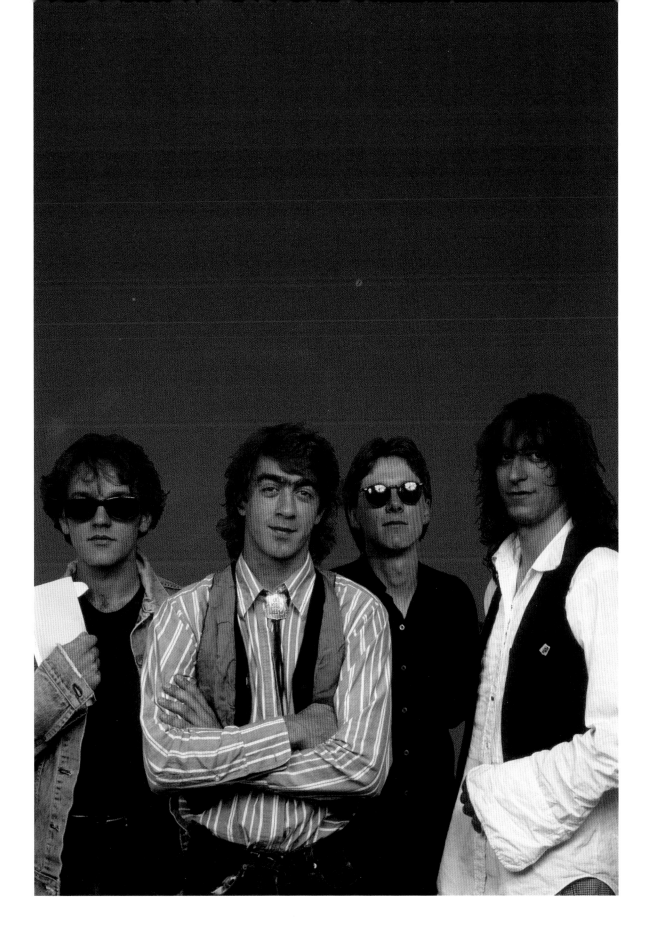

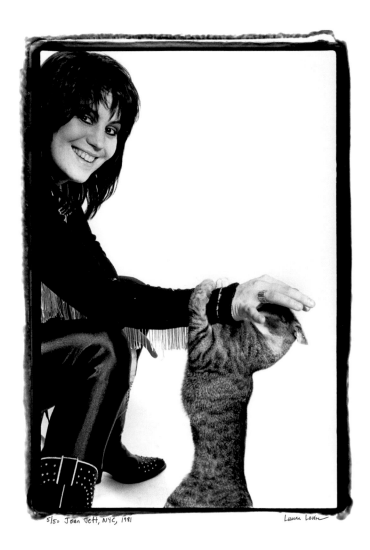

5/50 Joan Jett, NYC, 1981 Laura Levine

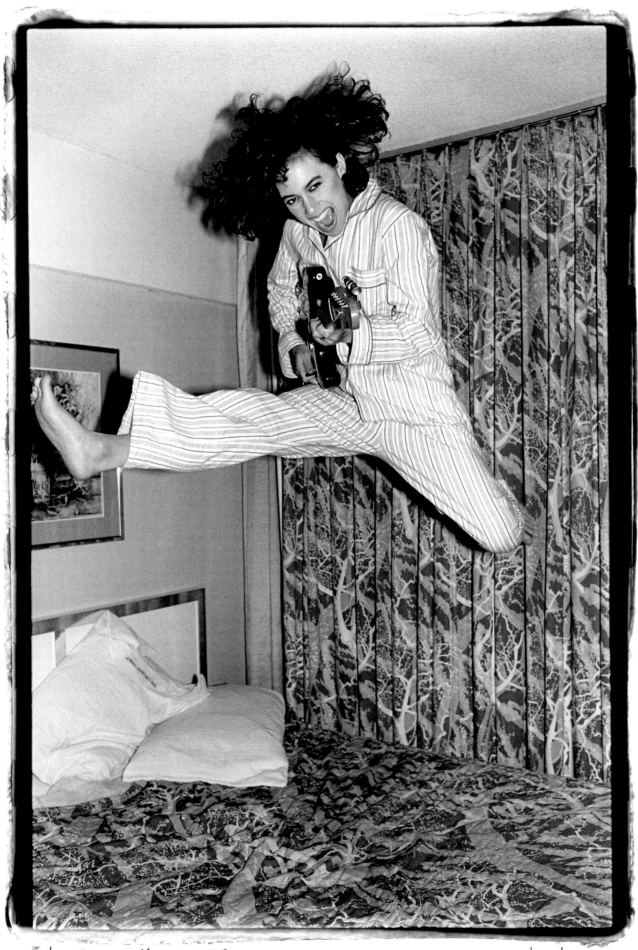

1/35 Susanna Hoffs, Boston, 1985 Laura Levine

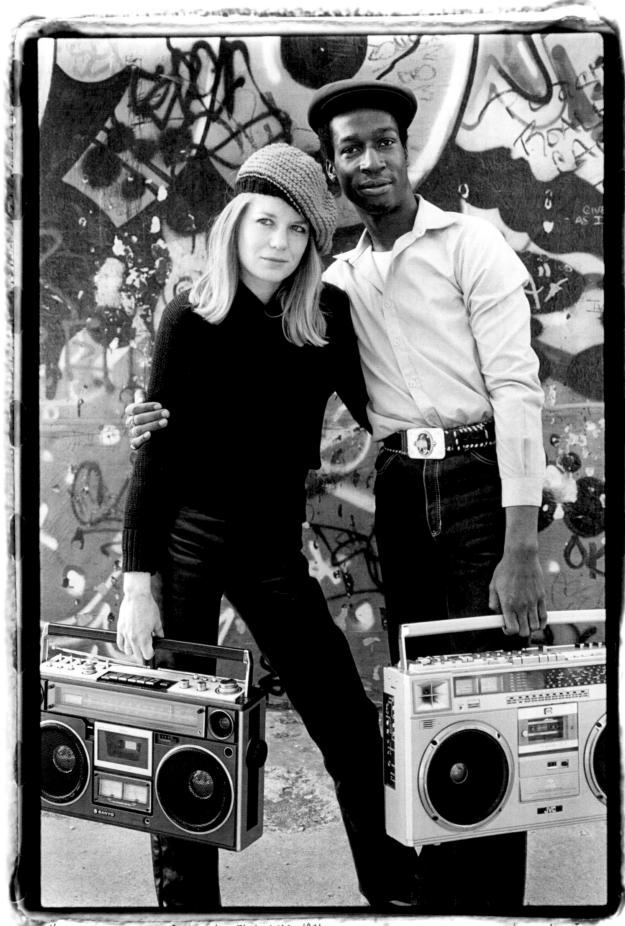

4/50 Tina Weymouth + Grandmaster Flash, NYC, 1981 Laura Levine

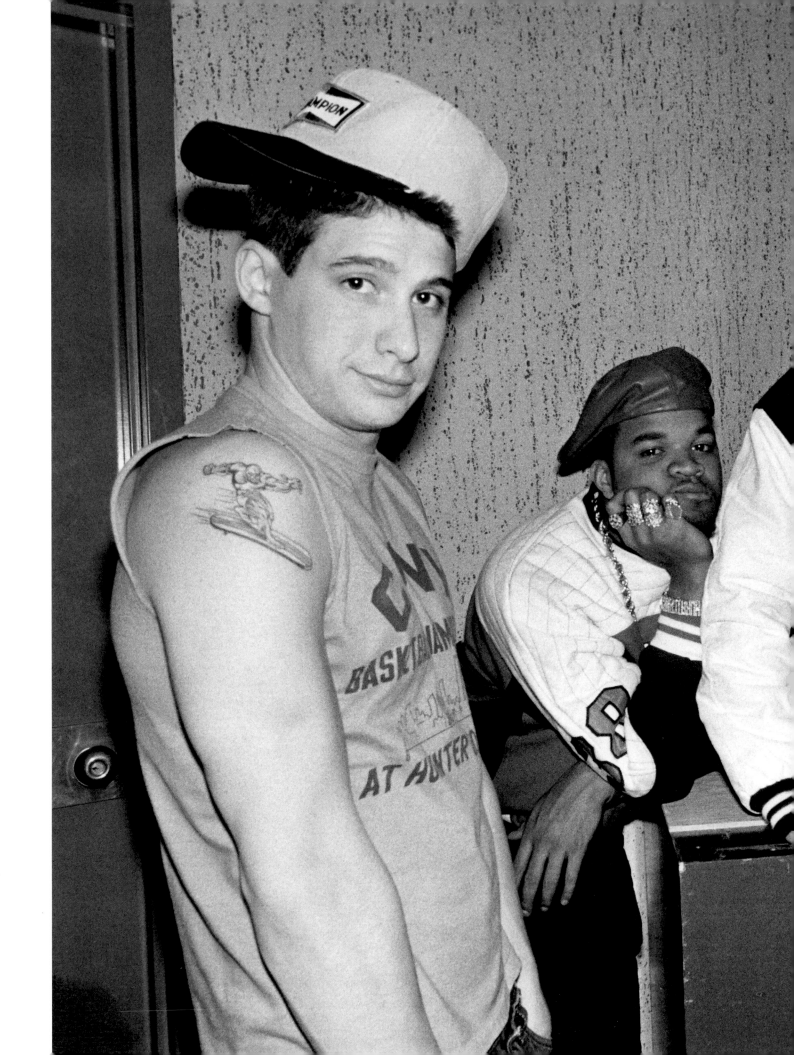

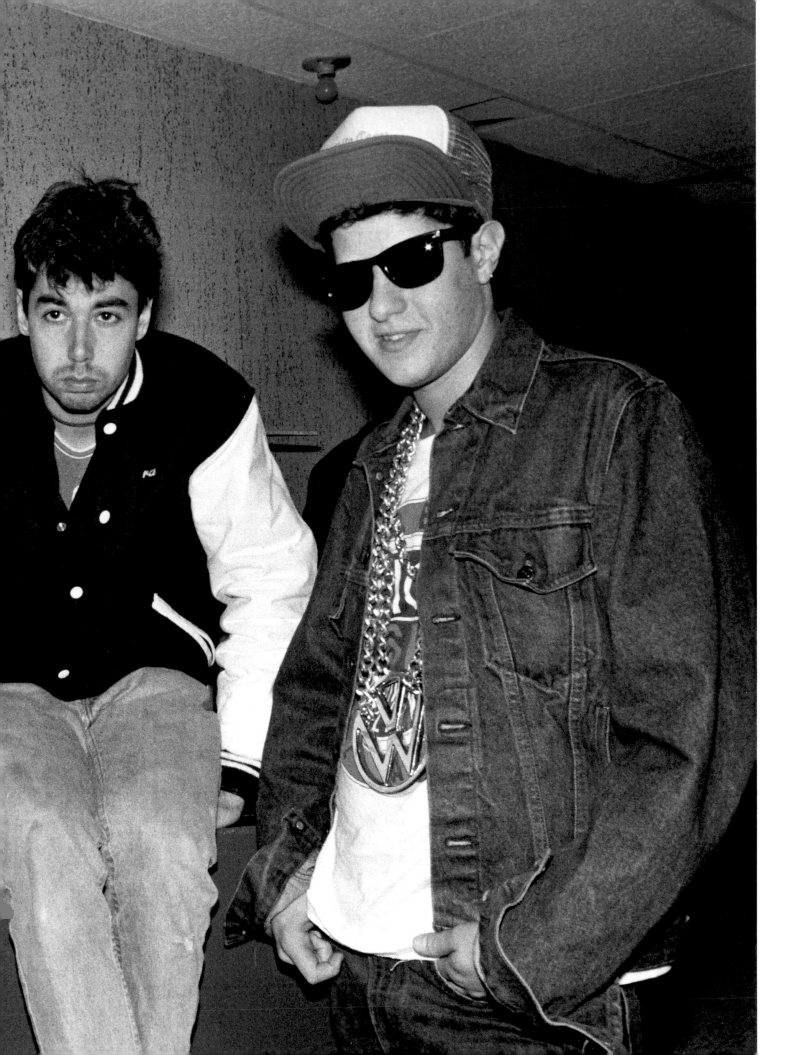

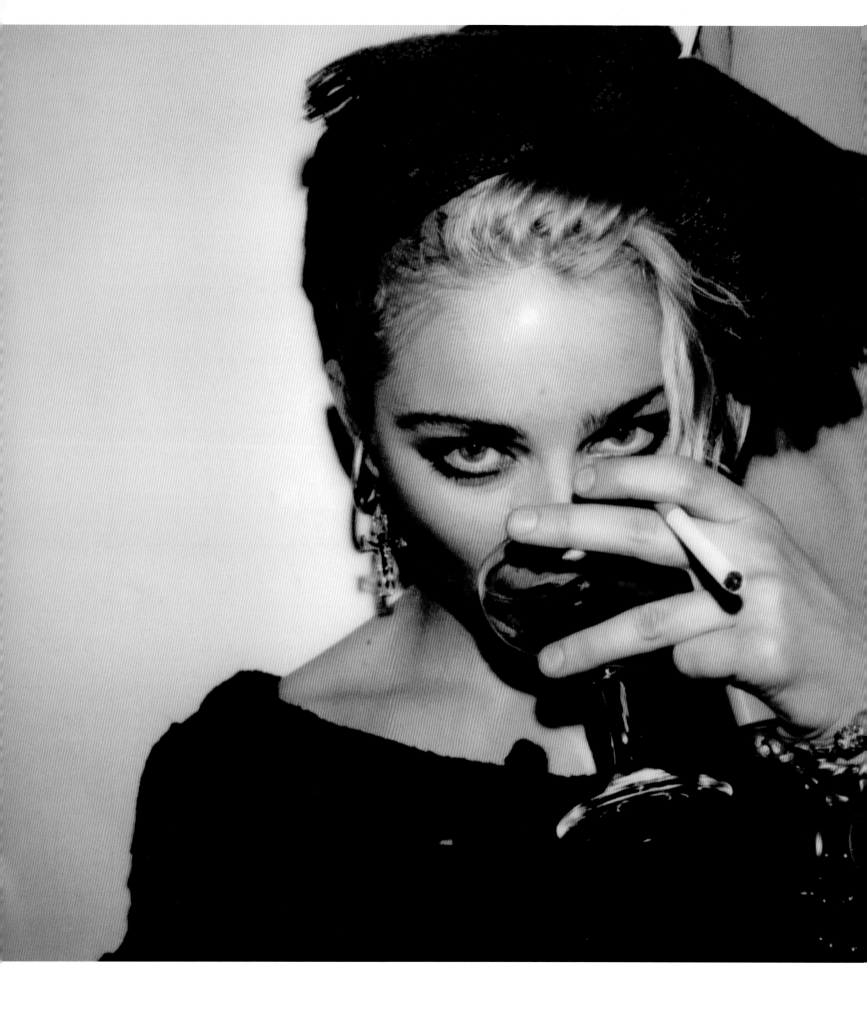

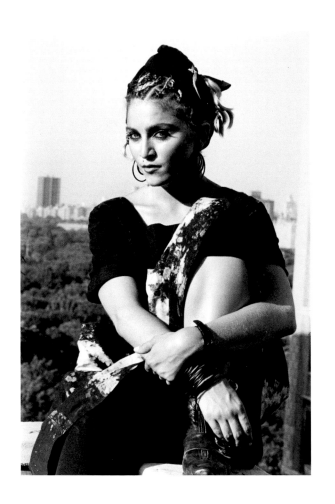

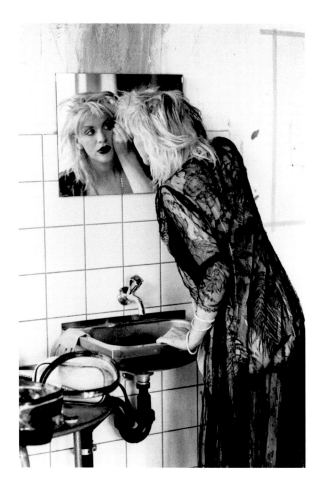

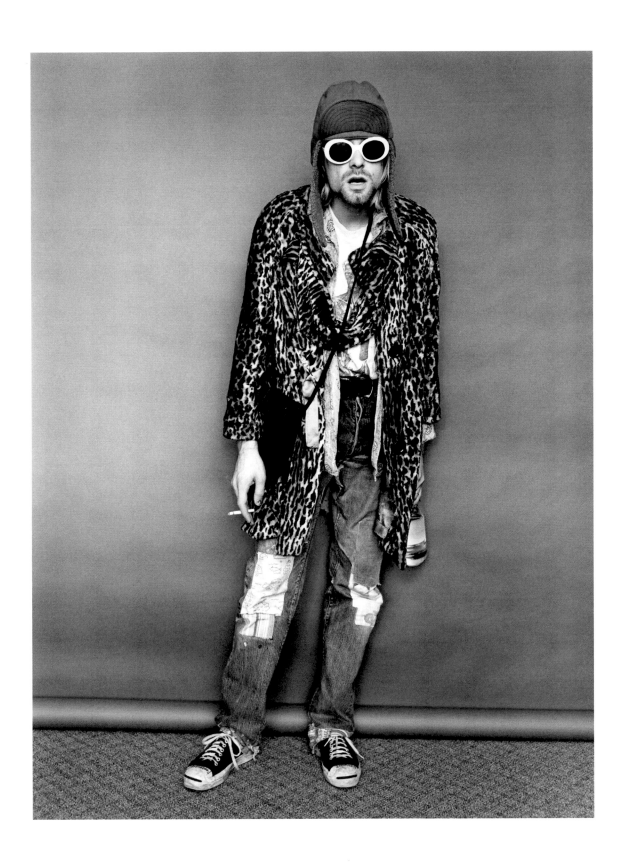

Interview with Kate Simon Thomas Denenberg

You are (partially) responsible for creating the mythology of rock & roll—did you know this at the time? No, I was shooting people. When I think of Led Zeppelin, I remember what a nice person Robert Plant was to work with on tour. I think of him as a man who lost his son. His son was six, and I remember that son, and that son was an unbelievably great kid. Was I myth-making? No. I couldn't even name a Led Zep song except for "Stairway to Heaven." **Why the camera?** When I was seven, my father showed me pictures of the Holocaust. He was a doctor in World War II on the front, and he wanted me to see these photographs. I eventually pilfered his Nikon FTn—a camera he coincidentally bought in Jamaica the year he died—and started my career. We lived in Poughkeepsie. My father was a lovely, lovely man, an achieved surgeon, a tennis umpire, chess champion, camera freak. Because he would photograph me and the family and he loved us, I came to associate photography with love. Taking pictures was a gesture of love. **From Poughkeepsie to Paris?** I went to George Washington University. In my second year I studied in Paris, met Jim Morrison. I didn't photograph him—don't get me started. I then went to the Corcoran School of Art. At that point I knew that I was supposed to be a photographer. After two and a half years of university, I found myself at Kennedy Airport leaving for London, telling my mother that I was going to be a photographer. "Catherine," she said, "you're crazy." **Why London?** Music saturated England. You had no choice but to be a music photographer. I never had a resume but got a job at Disk magazine, one of the weeklies at the time; you see Bob Dylan reading it in Dont Look Back. Walked into Disk, met the art director and the editor. Based on one photo I took of Elton John performing (killer picture, great shot, him at Christmas at the piano), they hired me as their staff photographer and thus began my career, in 1974. **When did you go to Jamaica?** I first met Bob Marley in 1976—I was there at the Lyceum when the live record was recorded. I went to Jamaica that year. Bob was brilliant, indescribably brilliant. He had such God-given talent. **Iggy Pop, 2007? How did you come to take the portrait? How well do you have to know someone to achieve such a haunting moment?** What happens in Vegas stays in Vegas. Taking a portrait is almost like being a psychiatrist. It's confidential. I am always deeply grateful if someone is kind enough and generous enough to allow me into their home to take their portrait. If they are going to take the time, then you need to be really focused. You are there to get the shot. You're a hunter. A benign hunter. Do I know him? Not at all. I had photographed him onstage and then I wanted to shoot him in repose. I purposely wanted to shoot him when he wasn't on tour. I love the image. It's so special the way the tilt of his head is parallel to Jesus. Their eyes are both blue, and Iggy looks so unmasked, so intelligent. Rock musicians are so good at masking; it is a privilege when they take off the mask. He sent me an e-mail after the shoot, and it was one of the nicest messages I've ever received. I wish more people did that because it's as if he gave me blood. He gave me life.

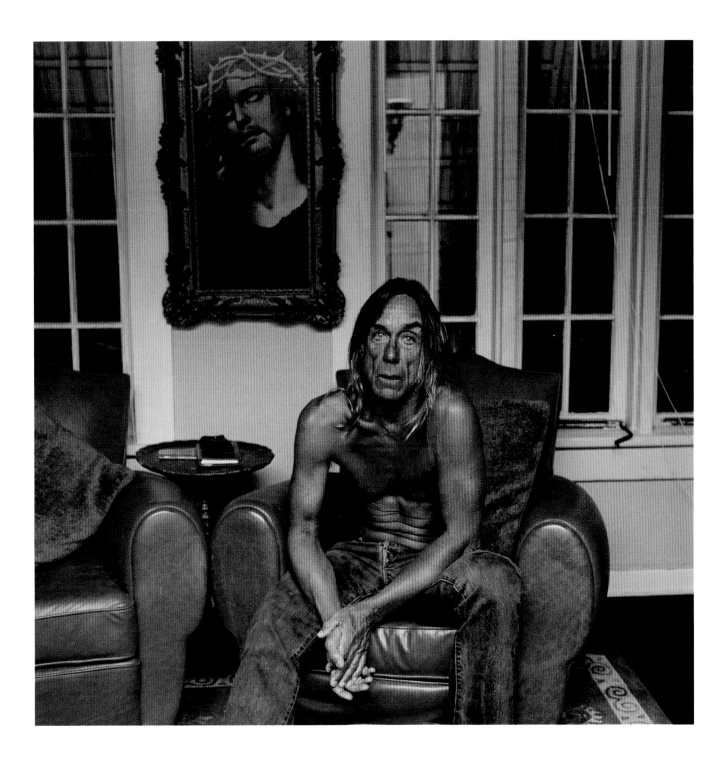

List of Plates
by page number

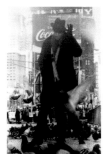

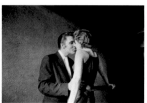

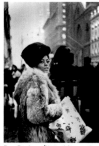

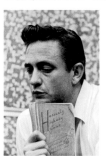

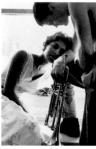

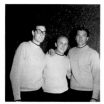

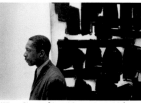

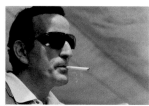

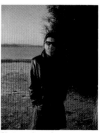

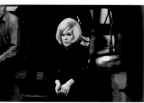

33 Lynn Goldsmith (United States, born 1948)
The Beatles, 1964

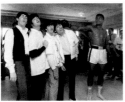

34 Harry Benson (Scotland, born 1929)
Ali Hits George, Miami, 5th Street Gym, 1964

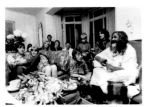

35 Philip Townsend (England, born 1940)
The Beatles with Maharishi, 1966

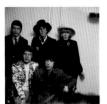

36 Eve Bowen (England, 1933–1985)
The Rolling Stones, 1967

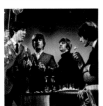

37 Photographer for <u>Mirabelle</u>
The Beatles, date unknown

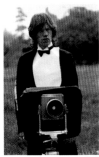

38 David King (England, born 1943)
Mick Jagger, 1968

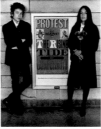

39 Photographer unknown
Brian Jones, 1967

40 Philip Townsend (England, born 1940)
Nico, 1964

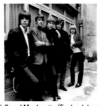

41 Mick Rosser (England, born 1943)
The Who as High Numbers, 1964

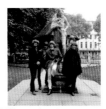

42 David Wedgbury (England, 1937–1998)
The Who, Ireland, 1966

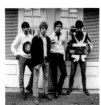

43 Mick Rosser, (England, born 1943)
The Animals, 1964

44 Barry Feinstein (United States, born 1931)
Paparazzi, Paris, France (Bob Dylan), 1966

45 Daniel Kramer (United States, born 1932)
Bob Dylan & Joan Baez with Protest Sign, 1964

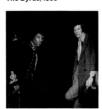

46 Gered Mankowitz (England, born 1946)
The Yardbirds, 1965

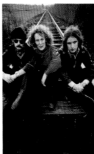

47 Photographer unknown
The Byrds, 1966

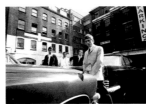

52 Herb Schmitz
Jimi Hendrix and Eric Clapton, 1967

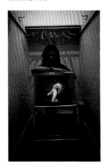

53 Art Kane (United States, 1925–1995)
Cream, 1968

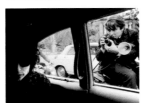

54 Art Kane (United States, 1925–1995)
Jim Morrison, 1968

121

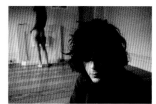

55 Mick Rock (England, born 1949)
Syd Barrett & Iggy the Eskimo, London, 1969

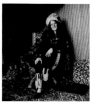

57 Baron Wolman (United States, born 1937)
Janis on the Throne, 1968

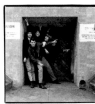

58 Herb Greene (United States, born circa 1943)
The Grateful Dead, circa 1965

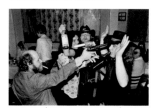

59 Kate Simon (United States, born 1953)
Lynyrd Skynyrd, Birmingham, 1975

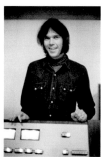

60 Bob Gruen (United States, born 1945)
Led Zeppelin – NYC, 1973

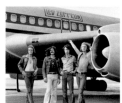

63 Baron Wolman (United States, born 1937)
Joni Mitchell, 1968

65 Photographer unknown
Eric Clapton and the Yoko Ono Band, 1969

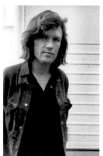

66 Baron Wolman (United States, born 1937)
Kris Kristofferson, 1968

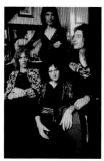

67 Baron Wolman (United States, born 1937)
Neil Young, 1969

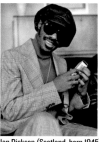

inside
front cover Ian Dickson (Scotland, born 1945)
68 **Stevie Wonder**, 1974

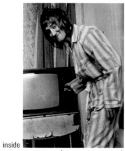

inside
back cover Ian Dickson (Scotland, born 1945)
69 **Rod Stewart**, 1974

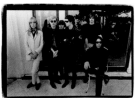

71 Gerard Malanga (United States, born 1943)
**Andy Warhol w/ the Velvet Underground &
Nico, Hollywood Hills**, 1966

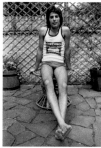

72 Ian Dickson (Scotland, born 1945)
Freddie Mercury, 1975

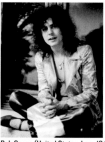

73 Paul Humberstone (England, born 1948)
Queen, 1973

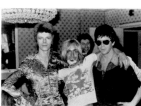

74 Bob Gruen (United States, born 1945)
Marc Bolan – NYC, 1971

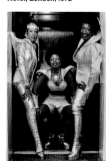

75 Mick Rock (England, born 1949)
**David Bowie/Iggy Pop/Lou Reed, Dorchester
Hotel, London**, 1972

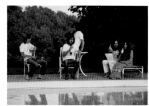

76 Ian Dickson (Scotland, born 1945)
Labelle, 1974

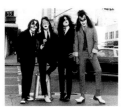

77 Bob Gruen (United States, born 1945)
KISS – NYC, 1974

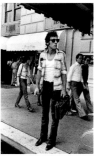

78 Lynn Goldsmith (United States, born 1948)
Bruce Springsteen, NYC, 1978

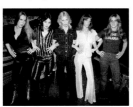

79 Bob Gruen (United States, born 1945)
The Runaways "My Father's Place" – NYC, 1976

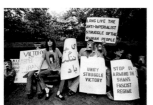

80 Lynn Goldsmith (United States, born 1948)
Patti Smith, Central Park, 1975

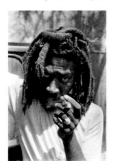

83 Kate Simon (United States, born 1953)
Bunny Wailer, Kingston, Jamaica, 1967

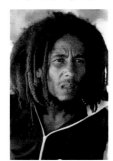

84 Kate Simon (United States, born 1953)
Bob Marley, Kingston, Jamaica, 1976

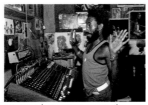

85 Kate Simon (United States, born 1953)
Lee "Scratch" Perry, Kingston, Jamaica, 1976

88 Kate Simon (United States, born 1953)
Grace Jones, NYC, 1978

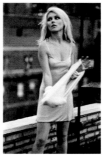

90 Bob Gruen (United States, born 1945)
David Johansen Dreams – NYC, 1978

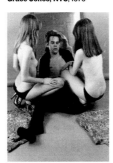

91 Laura Levine (United States, born 1958)
Joey Ramone, NYC, 1982

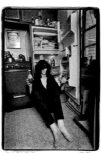

92 Bob Gruen (United States, born 1945)
Iggy Pop and Debbie Harry – Toronto, 1977

93 Roberta Bayley (United States, born 1950)
Chris Stein and Debbie Harry, 1976

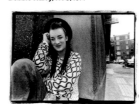

94 Roberta Bayley (United States, born 1950)
Anya Phillip and Stiv Bators, 1977

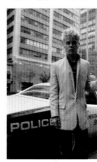

95 Kate Simon (United States, born 1953)
Debbie Harry, NYC, 1977

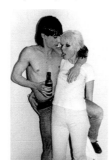

96 Laura Levine (United States, born 1958)
Boy George, London, 1982

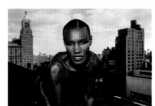

97 Roberta Bayley (United States, born 1950)
Billy Idol, 1978

123

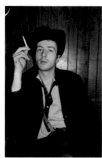

98 Roberta Bayley (United States, born 1950)
Joe Strummer, Times Square, 1980

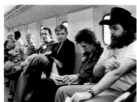

99 Bob Gruen (United States, born 1945)
Sid Vicious, Airport Bus, Baton Rouge, USA, 1978

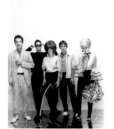

101 George DuBose (United States, born Morocco, 1951)
The B-52s, First Album Cover, 1978

102 Lynn Goldsmith (United States, born 1948)
Jerry Harrison, David Byrne, and Nona Hendryx, 1980

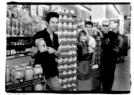

103 Laura Levine (United States, born 1958)
X, NYC, 1982

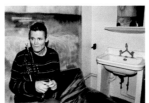

104 Claude Gassian (France, born 1949)
Chet Baker, 1986

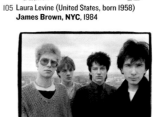

105 Laura Levine (United States, born 1958)
James Brown, NYC, 1984

106 David Corio (England, born 1960)
U2, Cork, Ireland, 1980

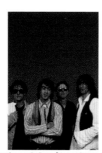

107 George DuBose (United States, born Morocco, 1951)
R.E.M., cover of <u>Spin</u> magazine, 1986

108 Laura Levine (United States, born 1958)
Joan Jett, NYC, 1981

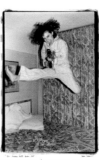

109 Laura Levine (United States, born 1958)
Susanna Hoffs, Boston, 1985

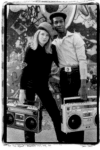

111 Laura Levine (United States, born 1958)
Tina Weymouth & Grandmaster Flash, NYC, 1981

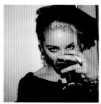

112 Bob Gruen (United States, born 1945)
Beastie Boys – NYC, 1987

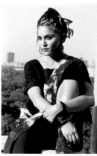

114 Maripol (United States, born France, 1955)
Madonna, 1982

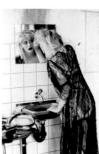

115 Kate Simon (United States, born 1953)
Madonna, NYC, 1983

115 Kevin Cummins (England, born 1953)
Courtney Love, Zurich, Switzerland, 1995

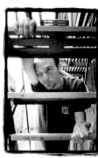

116 David Corio (England, born 1960)
Moby, Mott Street, NYC, 1992

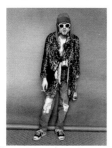

117 Jesse Frohman (United States, born 1968)
Kurt Cobain, 1994

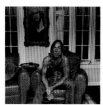

119 Kate Simon (United States, born 1953)
Iggy Pop, Miami, 2007

back Laura Levine (United States, born 1958)
cover **Sinead O'Connor, NYC**, 1988

Acknowledgments

Rock & roll has always been about the crowd, and a large number of people came together to make this project happen. First and foremost, I would like to thank Greil Marcus, Anne Wilkes Tucker, Laura Levine, Glenn O'Brien, and Kate Simon for their keen words and images; Margo Halverson and Charles Melcher of Alice Design Communication for the elegant book; Sandra Klimt, Thomas Palmer, and Rickie Harvey for meticulous production and editing; Patricia Fidler and Michelle Komie at Yale University Press for their constant support; and Chris Walsh, Thomas DuBrock, Corey Brayton, Doyle Russell, Mike Hollis, Susanne Tatum McCurry, and Robyn Molen for making it all happen. An earlier version of Glenn O'Brien's essay appeared in <u>Perspectives 149: It's Only Rock and Roll</u>, a publication of the Contemporary Arts Museum Houston.

At the Portland Museum of Art I am grateful to my colleagues who helped to edit this catalogue and organize the accompanying exhibition: Dana Baldwin, Susan Danly, Amber Degn, Julia Einstein, Kris Kenow, Teresa Lagrange, Marilyn Lalumiere, Kristen Levesque, Sage Lewis, Karin Lundgren, Elena Murdock, Vanessa Nesvig, Daniel O'Leary, Jackie Richardson, Stacy Rodenberger, Lauren Silverson, Sarah Stiles, Ellie Vuilleumier, and Greg Welch. Erin Damon deserves special mention for her organizational skills and good humor.

We are particularly grateful to the Contemporaries and The VIA Group for their generous support of this exhibition and catalogue. Under the leadership of Chris Robinson and Alex Fisher, members of the Contemporaries raised funds for this project and made it their own. At VIA, we thank John Coleman and Rob Gould for their enthusiastic support of this catalogue, the Portland Museum of Art, and our city.

Our largest debt of gratitude is owed to the man who gathered these photographs, lent them to the museum with infectious enthusiasm, and only insisted on intellectual rigor in return. I hope he enjoys the show.

Thomas Andrew Denenberg
Chief Curator and
William E. and Helen E. Thon Curator of American Art
Portland Museum of Art, Maine

Photography Credits

All the prints illustrated here are in a private collection. Aside from those works that are in the public domain, nearly all of the images reproduced in this volume are copyrighted by their makers or their families, estates, and related foundations. Every effort was made to contact the artists or their representatives, and we thank them for their reproduction permissions listed below:

Roberta Bayley, pp. 93, 94, 97, 98
© Harry Benson, p. 34
Eve Bowen/Photo © Mark and Colleen Hayward, p. 36
© Emil Cadoo/Courtesy Janos Gat Gallery, p. 22
William Claxton/Courtesy Demont Photo Management, pp. 23, 25, 28
© David Corio, pp. 106, 116
© Kevin Cummins 1995, p. 115
Photograph by Ian Dickson/www.late20thcenturyboy.com, pp. 68, 69, 72, 76
© George-DuBose.com, pp. 3, 101, 107
Barryfeinsteinphotography.com, p. 44
© Lee Friedlander, courtesy Fraenkel Gallery, San Francisco, p. 31
© Jesse Frohman, p. 117
Photograph © Claude Gassian, p. 104
© lynn goldsmith, pp. 33, 78, 80-81, 102
Photo © Herb Greene, p. 58
© Bob Gruen/www.bobgruen.com, pp. 60-61, 74, 77, 79, 90, 92, 99, 112-113
Photo © Mark and Colleen Hayward, pp. 24, 29, 30, 33, 37, 39, 47, 65
Paul Humberstone/Photo © Mark and Colleen Hayward, p. 73
© Art Kane Archive, pp. 15, 53, 54
David King/Photo © Mark and Colleen Hayward, p. 38
© Daniel Kramer, p. 45
Laura Levine, pp. 91, 96, 103, 105, 108, 109, 111, back cover
Photo © Gerard Malanga, p. 71
Copyright Bowstir Ltd 2008/mankowitz.com, p. 46
MARIPOL, p. 114
Don Paulsen/© Getty Images, p. 20
Photos12.comJean-Marie Périer, pp. 5, 32
Copyright Mick Rock 1969, 1972, 2008 www.mickrock.com, pp. 55, 75
Mick Rosser/Photo © Mark and Colleen Hayward, pp. 41, 43
Herb Schmitz, p. 52
© Kate Simon, pp. 59, 83, 84, 85, 88, 95, 115, 119
© Philip Townsend Archive, cover, pp. 2, 10, 35, 40
David Wedgbury/Photo © Mark and Colleen Hayward, p. 42
© Leigh Weiner, p. 21
© Alfred Wertheimer/Contact Press Images, p. 12
Photo © Baron Wolman, pp. 57, 63, 66, 67

This book was published in conjunction with the exhibition
Backstage Pass: Rock & Roll Photography, January 22–March 22, 2009.

Copy edited by Fredrica Harvey, Boston, Massachusetts

Designed by Margo Halverson, Charles Melcher, Alice Design
Communication, Portland, Maine

Production by Sandra Klimt, Klimt Studio, Inc., Falmouth Foreside, Maine

Digital captures by Thomas DuBrock, Houston, Texas

Separations by Thomas Palmer, Newport, Rhode Island

Printed by Meridian Printing, East Greenwich, Rhode Island

Bound by Acme Bookbinding, Charlestown, Massachusetts

Set in Akzidenz Grotesk, Alphatier, Folio, Knockout, and Monotype Grotesque

Library of Congress Control Number: 2008937656
ISBN: 978-0-300-15163-3

Front cover: Philip Townsend (England, born 1940), <u>Andrew Loog Oldham</u>,
1963 © Philip Townsend Archive
Back cover: Laura Levine (United States, born 1958), <u>Sinead O'Connor, NYC</u>,
1988 © Laura Levine